Historic Tales

of

BETHLEHEM

NEW YORK

D1484204

Historic Tales
of
BETHLEHEM
NEW YORK

SUSAN E. LEATH

THE
History
PRESS

Published by The History Press
Charleston, SC
www.historypress.net

Front cover, top: Studler's 1955 Tri-Village Little League team. *Courtesy of the Town of Bethlehem*; *bottom*: Bridge Street in South Bethlehem looking east. *Courtesy of the Bethlehem Public Library*. *Back cover, top*: Delmar Fire Engine Company No. 1. *Courtesy of the Town of Bethlehem*; *bottom*: A view of the Normans Kill Creek at Kenwood. *Courtesy of the Town of Bethlehem*.

First published 2016

Manufactured in the United States

ISBN 978.1.46711.855.2

Library of Congress Control Number: 2015955756

CONTENTS

PREFACE

In December 2012, John Guastella, publisher of *Our Towne Bethlehem*, approached me about writing a series of "Then & Now" articles for his publication. A tireless Bethlehem booster, John recognized the appeal of historic images and the curiosity folks have about local history. I recognized an opportunity for my articles to reach a wider audience with the added bonus of a monthly deadline. Now those articles would get written and not remain stuck in my head. A partnership was born.

This book compiles those article as well as others I have written in my years as Bethlehem's town historian. All of my author royalties will be donated to the Bethlehem Historical Association.

EXPLORING BOXES

The town of Bethlehem is fortunate to have a collection of records dating back to the 1700s. They include a wide variety of documents, maps and images. While some records, especially related to town government, are fairly comprehensive, others have arrived in the collection in a hit-or-miss fashion. For example, town meeting and town board records go from 1794 to the present without a break. Deeds and land indentures are more sporadic. I wrote this article when I was first appointed town historian in September 2007.

As the new town historian, one of the most intriguing parts of the job is becoming familiar with the town archives. Just glancing through the index raises all kinds of questions about our town's history. Box AR 17 has something called "Dog Quarantine 1930." Box AR-05 has "1932 Deposition, *Ten Eyck v. Van Der Zee*." How about "Men from Slingerlands—WWI Military Service" or "Application for Water"? Box AR-06 lists "Old Recipes." Another box lists "Misc. deeds and wills 1794–1907." These are just a sampling of the many items listed in the index to the archives. Did I mention photographs? The index lists 1,660 of those. What a deep and rich history the town of Bethlehem has.

What about that dog quarantine of 1930? It turns out the dogs weren't quarantined because they were sick; they were just misbehaving. Dogs running loose was such a problem that the town board passed a quarantine resolution in November 1930. This resolution was superseded by the quarantine notice issued by the commissioner of agriculture and markets

A view of the boxes in archival room number one at Bethlehem Town Hall. *Courtesy of the author.*

ordering that all dogs in Albany County, including Bethlehem, be "securely confined between sunset and one hour after sunrise during the period from December 3, 1930 until this order is revoked." The item in the archives is a copy of this county-wide ban.

The archives also contain a letter dated September 3, 1919, from Henry L. Taylor, Graceland Farm, to George H. Coughtry, Bethlehem town clerk. Taylor writes, "I received by phone information that dogs were worrying our sheep. I at once directed three men to protect the sheep and while endeavoring to catch two dogs, one was shot and killed." Here is evidence that those roaming dogs caused problems for the farmers.

It wasn't just dogs roaming about in the early days of our town. Roaming cattle, swine and horses were also a problem. The 1794 minutes of the town of Bethlehem included a resolution that "no stallions, swine, or unruly cattle shall be allowed to run at large in the public Highways." Town pound masters were elected to round up stray animals and identify their owners. Owners then paid a fine to retrieve their animals. In 1794, Bethlehem's pound masters were Walter Hooghtelin and Teunis W. Slingerland.

As town historian, I will continue to explore, and add to, these intriguing boxes.

Part I

COMMUNITY

Chapter 1

BETHLEHEM PUBLIC LIBRARY CELEBRATING ONE HUNDRED YEARS

This article was first published in the May 2013 issue of Our Towne Bethlehem. *It has been updated.*

In 1913, the women of the Delmar Progress Club were searching for a way to invest in their community for the long term. Their vision—to create the Delmar Free Library—became a reality that has survived and thrived for over one hundred years.

The Delmar Progress Club was established in 1901 for the "mental, moral and social development of its members, and the civic betterment of the community." Eleven women responded to the initial call to establish the club. Twelve years later, Mrs. Frank Sharpe suggested the group found a library, and at their April 14, 1913 meeting, the club voted "to undertake the matter of installing a free library in the school building."

That school building was the Delmar Grade School–District School No. 10. Today the building is the Masonic Temple located at the corner of Kenwood Avenue and Adams Street. The library was located in a single second-story room and opened for the first time on August 16, 1913. The library's first annual report, submitted to the New York State Education department after only ten months of service, noted 253 registered borrowers with a total free circulation for home use of 4,298. In contrast, the library's 2013–14 total book circulation was 465,561.

Just three years after its founding, the Progress Club found the schoolroom inadequate for the services it was providing. After some negotiation, the club

accepted land from the George C. Adams estate and began fundraising for a new library building. The new 720-square-foot building at the corner of Adams Street and Hawthorne Avenue opened in 1917. The design of the building was donated by Walter P.R. Pember, a local architect whose wife was a Progress Club member.

Throughout these early days, the library was staffed by volunteers, many of whom were Progress Club members. With the ever-increasing popularity of the library, a professional staff became necessary. In 1931, the Delmar Progress Club turned over the operation of the library to the Bethlehem Central School District. The school district hired Eula Hallam as librarian. She presided over 2,750 books and ordered the library's first magazine subscription. Hallam also drove the first bookmobile in December 1931. The bookmobile contained 400 books, and its route covered much of Bethlehem, including stops in Slingerlands, Elsmere, Normansville, Glenmont and Van Wies Point. While the last bookmobile, Babe, was retired in 1976, delivery of library materials to the homebound continues to this day.

The tiny stucco and brick library building served the community for many years. The year 1954 saw the first significant renovation, increasing the size by more than six thousand square feet. Twenty-five thousand books could now be accommodated, as well as a children's room, an adult reading room, a community room, a bookmobile garage and more. Bethlehem and

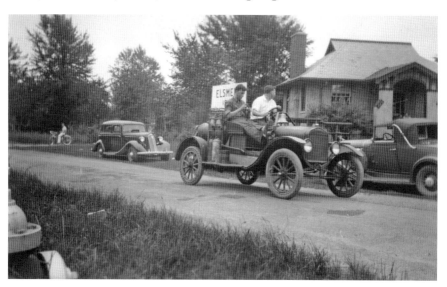

The Delmar Free Library's 1917 building at the corner of Adams Place and Hawthorne Avenue, circa 1935. *Courtesy of the Bethlehem Public Library.*

The expanded library building about 1971. *Courtesy of the Bethlehem Public Library.*

its library were still growing. In the late 1960s, plans were underway for a new building, and in 1969, the name was changed to the Bethlehem Public Library. Librarian Barbara Rau's vision for an accessible, centrally located building that could accommodate an ever-expanding circulation of books and knowledge was approved by voters in 1969.

Architect Howard Geyer designed a modern building suited to the property at the corner of Delaware and Borthwick Avenues. It could hold 120,000 books. In May 1972, the huge task of packing and moving into the library's new home became a community-wide effort. Patrons were encouraged to check out extra books from the Adams Street location and return them to the new building. Late book fines were waived for the month of May. Girl Scouts, Boy Scouts, members of the Tri-Village Welcome Wagon, high school students and even a local group from the National Guard pitched in to move furniture, shelving, books, magazines and records.

Geyer's award-winning library design continues to be the home of the Bethlehem Public Library, with its exterior footprint little changed since it opened its doors in 1972. Inside, many changes are visible that reflect a vibrant, up-to-date library facility. Louise Greco, in her book *They Built Better Than They Realized: A Centennial History of the Bethlehem Public Library*, says it

best: "Technology has stormed the library world, revolutionizing cataloging and circulation, changing the way we think about and conduct research, linking libraries and their resources locally, regionally and globally."

Today, Bethlehem is one of the busiest libraries in the Capital Region, with an almost $4 million budget, seventy-five full- and part-time employees and 102,500 books. The total circulation of 714,680 includes not only books but also magazines and audiovisual items, according to the Bethlehem Public Library 2013–14 Annual Report. The mission statement sums up a modern commitment to community and education that certainly serves the Progress Club's 1913 vision:

> *Bethlehem Public Library values its responsibility to enhance the general welfare and quality of life in the community and region it serves. The library pursues excellence in its mission: to provide equal and uncensored access to resources and services that encourage lifelong learning, cultural enrichment, and professional growth.*

For many years, the former library building on Adams Street housed Bethlehem Central School District's administrative offices. They moved out in April 2012 and placed the property up for sale. During 2014, the building was sold and substantially demolished to make way for a doctor's office.

Chapter 2

THE DELMAR SCHOOL

This article was originally published in the November 2013 issue of
Our Towne Bethlehem.

New York, with its Dutch heritage, has always been a supporter of education. At the opening of the legislative session in 1795, Governor Clinton expressed his support of public schools, and within a few months, the state legislature had appropriated funds for encouraging and maintaining schools in the state. The passage of the Common School Act of 1812 continued this state support.

By the 1850s, the town of Bethlehem had fourteen common school districts. District #10 at Adamsville (later known as Delmar) had its one-room schoolhouse near the intersection of today's Kenwood Avenue and Adams Street.

The first record we have for the District No. 10 school comes from the annual meeting of 1845. Nathaniel Adams was appointed secretary, twenty-five dollars was to be raised for fuel and other expenses and A.B. Wilder was chosen as teacher. In 1847, Mr. Cole was appointed teacher at a salary of sixteen dollars per month, and he was "boarded around with inhabitants" of the district. In 1851, a new brick school was decided upon, with the old one to be sold to the highest bidder.

In 1883, the district had 139 children of school age, with 97 of them in attendance. The school year was ten months long. The year 1887 saw the installation of slate blackboards, and in 1894, two female teachers

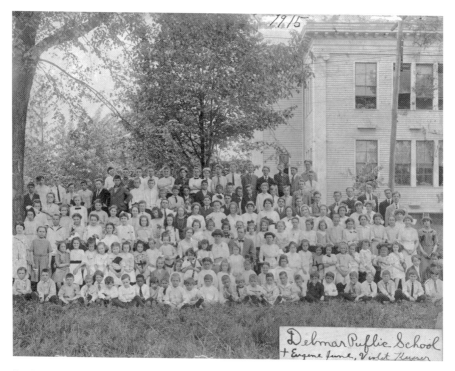

Students and teachers pose in front of the Delmar School in 1915. *Courtesy of the Bethlehem Public Library.*

The Delmar School about 1930, shortly after it was sold to the Masonic Temple. *Courtesy of Ann Vandervort.*

were employed: Miss Udell at eleven dollars per week and Miss Gertrude Haswell at nine dollars per week. Teachers focused on the basics of reading, writing and arithmetic for grades one through eight. With growth in Delmar forecast, a new and larger school building was desired.

The District No. 10 school building extant today still reflects the original ideas from the annual district meeting held on August 7, 1906. Recommendations were for a two-story frame building of a size for one hundred pupils in two rooms with a suitable hall and wardrobes. The second story was not to be finished beyond the laying of the floor. Bricks from the old school were to be used for the foundation and basement. The exterior was to be "plain colonial." At the January 22, 1907 special meeting, the proposition to build the new school at a cost of $6,000 was passed. Another special meeting was called in April to raise an additional $3,700.

With Delmar's growing population, this building was in use for about eighteen years before a new, modern school was deemed necessary. The Delmar School on Delaware Avenue opened in 1925, and the one on Kenwood closed. The building on Kenwood was sold to the Bethlehem Masonic Lodge in 1929, and it remains in that group's hands today. The Delmar School on Delaware thrived as part of the Bethlehem Central School District until it, too, grew outdated and students were transferred to other schools, including the new Hamagrael Elementary School. In 1980, the building was sold to the town, and it has served as Bethlehem's town hall ever since.

Chapter 3

BETHLEHEM BASEBALL

Updated from the August 2014 edition of Our Towne Bethlehem.

Bethlehem residents have enjoyed a long relationship with the game of baseball. Notable teams include the Echo of Slingerlands, which played from about 1889 to 1895. From the early 1900s until about 1915, the Village Wonders were a strong team from Slingerlands. Slingerlands and Delmar had teams from the 1910s right up to the 1930s. South Bethlehem also fielded a team as early as 1907, and it played against Slingerlands in the late 1920s in the Suburban Baseball League. The Tri-Village Little League and Bethlehem Babe Ruth got going in the 1950s and continue strong today.

The Slingerland Village Wonders organized about 1901. These talented players swung their bats on a ball field that was just north of today's Cherry Arms Apartments on the west side of Cherry Avenue. Later, the diamond was moved to near today's Kenwood and Union Avenues. By 1909, yet another field was utilized at the end of Mullens Road in Slingerlands. They were a part of the Susquehanna League, which was organized around villages along the Delaware and Hudson (D&H) Railroad line. Teams came from Delanson, Guilderland, Altamont, Voorheesville, Slingerlands and Delmar. The September 4, 1908 edition of the *Altamont Enterprise* notes that over five hundred people watched the baseball game against the Altamont team. It was described as "A Snappy Game from Start to Finish." While the Village Wonders disbanded around 1915, Slingerlands continued to field other teams as part of the Albany County League.

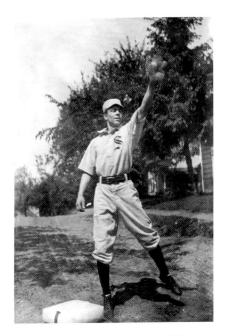

Clarence Earl of the Slingerland Village Wonders makes the catch. *Courtesy of the Town of Bethlehem.*

One player was Adam Mattice. Mattice (1863–1917) played baseball for several teams in Albany and Schoharie Counties in the 1880s and '90s, including Central Bridge and the Slingerland Echo. He might even have played for the Altamont Stars. Mattice was known for his curve ball. An undated newspaper clipping notes, "Although there were pitchers in Albany familiar with the use of the curved ball, Mattice was the first to introduce it in this vicinity, and by its use became practically invincible when opposing the old school of sluggers accustomed only to the swift straight kind."

The *Albany Evening Journal* of March 23, 1903, recalls the unusual game from 1882 that featured Mattice's pitching for Central Bridge. It goes on to note, "He is now living in Slingerlands and is a train dispatcher for the Delaware & Hudson railroad, being as expert with the telegraph key as he was years ago with the baseball." The unusual part of the game involved a betting scheme gone awry.

Delmar also had baseball teams that played for the Susquehanna League, the Albany County League and as independent clubs. Its first field, Station Field, was near Delmar's stop on the D&H Railroad, which was at the intersection of today's Hudson Avenue and Adams Street. Later, the teams played near today's town hall on Delaware Avenue and later still at Brockley Field near today's high school.

Bloomer Girl teams also made appearances in our area. The Knox team played the Stanford Heights Bloomer Girls in September 1921. The Bloomer Girls were said to be a fast team, and the game was expected to be a "hummer." The September 2, 1921 *Altamont Enterprise* urged readers "that have not seen girls play real baseball should not miss the opportunity." Admission to the game was twenty-five cents. Slingerlands played the New York City Bloomer Girls in 1929 and had a scheduled game rained out in 1930. The Electric City and Mohawk Giants Bloomer Girls also played in the area.

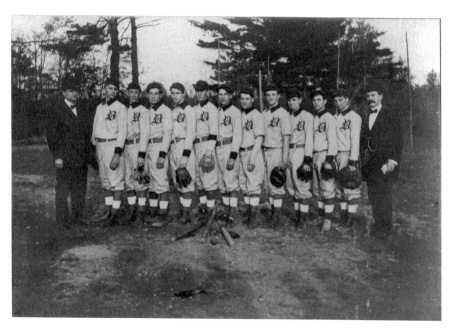

The Delmar Baseball Team. *Courtesy of Kathy Volo.*

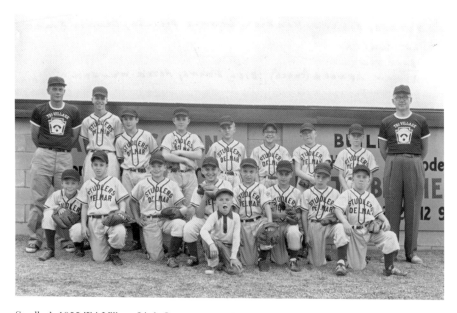

Studler's 1955 Tri-Village Little League team. *Front row, left to right*: Randy McKendry, Richard Cornell, James Prentice, Patrick Tuzzolo, Ronald Herrick, Dennis DiLillo, Dennis Emery, John Walsh. *Back row*: Adrian Arnold (coach), Bill Evans, Peter Wenger, William Walsh, Roger Burlingame, Chip Walsh, Tom Abele, Peter LaFond, William Walsh (manager). In front is Craig Herrick, batboy. *Courtesy of the Town of Bethlehem.*

Little League has its roots in Williamsport, Pennsylvania, where the first Little League game was played on June 6, 1939. Littleleague.org reports that "the basic goal remains the same as it did in 1939, to give children of the world a game that provides fundamental principles (sportsmanship, fair play and teamwork) they can use later in life to become good citizens."

Bethlehem's Tri-Village Little League held its first tryouts on April 3, 1954, at Bethlehem Central Junior High School (present-day Middle School), and the first games were played on May 15 at Magee Park on Kenwood Avenue. Four teams were organized, sponsored by F.F. Crannel Lumber Co., Carroll Pharmacy, Studler's Sales and Services and Main Brothers Oil Co. Crannel's took the league championship that year with a record of twelve wins and one loss. Sixty years later, the league still plays at Magee Park.

In April 1955, efforts were underway to organize the Bethlehem Babe Ruth League for players between the ages of thirteen and fifteen. The season opened on June 27 with four teams sponsored by Redmond & Bramley, Handy Dandy Cleaners, Heath's Shady Lawn Dairy and Franchini Painters & Decorators. Games were played at the junior high school. Today, the league consists of ten teams. Their games are held at the ball fields on Line Drive.

Chapter 4

ONE-ROOM SCHOOLS

Jericho and Bethlehem Church

Originally published in the February 2014 issue of Our Towne Bethlehem, *this article has been updated.*

People often wonder how town of Bethlehem students ended up in three different school districts: Bethlehem Central, Ravena-Coeymans-Selkirk and Guilderland. The answer goes back to the one-room schools that once blanketed the town.

By the 1850s, Bethlehem had fourteen school districts, each independently operated by supervisors elected from the district. Taxes were collected, a one-room schoolhouse was maintained and a teacher was hired to serve grades one through eight. The one-room school often became the center and focus of the rural communities.

Consider the Jericho School, District No. 4. Today, the original schoolhouse with its thirty-six-inch-thick fieldstone foundation is a private home on Creble Road complete with pink siding added in the 1950s. But 120 years ago, it was the center of a community known as Jericho, with families like the Van Allens, Winnes, Lukes, Moshers, Mallorys and VanDerZees in the neighborhood. When the one-room school was no longer adequate, a larger brick school was built nearby on today's Old School Road. The *Altamont Enterprise* in the late 1920s and early '30s announced a plethora of dances and card parties held at the school, a tradition that the PTA carried on well into the 1950s.

Today, the place name Jericho is remembered in the name of Jericho Road, which was the road *to* Jericho. Over the years, the layout of

The former District No. 4 one-room school located on Creble Road. It is now a private residence. *Courtesy of the author.*

Jericho Road, Creble Road, Long Lane and Old School Road has changed and industries, including the massive Selkirk Rail Yard, have moved in, yet in many ways the area's rural character remains. By the time Jericho School closed in the 1970s, it was serving just kindergarten and first grade.

Consider the Bethlehem Church School, District No. 5, also known as the Niver School. This one appears to have remained a one-room school right up until 1947, when the Union Free School District was organized. In 1948, the school and premises were auctioned off, and it has been a private residence ever since. It gets its name from the First Reformed Church of Bethlehem, which is located just down the road on Route 9W.

The Niver family, the school's other namesake, was prominent in town affairs. Family members include Revolutionary War veteran David Niver, town clerks David N. Niver (1856–58) and Charles A. Niver (1884) and town supervisor Charles D. Niver (1910–23). One remarkable Niver is Gerrit H. Niver. He enlisted with the Seventh U.S. Cavalry in 1873 at the age of twenty-seven under the assumed name of Gerrett H. VanAllen. Family lore has it that he used an alias to protect his mother. He headed west with the

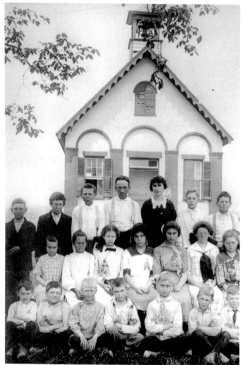

Above: A close-up of the District No. 4 school building on Old School Road. *Courtesy of the author.*

Left: Students pose in front of the District No. 5 one-room school about 1910. *Courtesy of the Town of Bethlehem.*

cavalry along with its leader, Lieutenant Colonel George A. Custer. Niver met his death at Custer's Last Stand, or the Battle of Little Big Horn, in Dakota on June 25, 1876.

The early twentieth century saw a changing society that called for improved educational opportunities, especially at the secondary level. Educators and parents began to realize the benefits to be gained from consolidating and centralizing the schools. The northern part of town went first with the creation of the Bethlehem Central School District in 1930. In 1947, the Union Free School District was formed from nine districts in the southern part of Bethlehem, including Jericho and Bethlehem Church, plus districts from the towns of Coeymans and New Scotland. After a controversial vote in 1955, Union Free became part of the combined Ravena-Coeymans-Selkirk Central School District. Today, the Albertus W. Becker School and Peter B. Coeymans School, both constructed in 1962, serve elementary-age schoolchildren in the RCS school district. Bethlehem's District No. 14 one-room school in North Bethlehem became part of the Guilderland Central School District when it was organized in 1954.

South Bethlehem
United Methodist Church

Originally published in the October 2014 issue of Our Towne Bethlehem.

30 dwellings, 33 families, 135 inhabitants, M.E. Church, school-house, 2 stores (kept by E.C. Palmer and Peter Grinder), shoe shop, harness, blacksmith and wheelwright shops, barber's room and saloon. It has a band of 12 musicians, with O.S. Jolley as leader.

This is how the hamlet of South Bethlehem was described in 1886 in Howell and Tenney's *Bicentennial History of Albany County*. Everything needed to sustain the surrounding farms was there. The description omits the railroad station, which provided important transportation for crops and people, and the post office. Today, the only things left on that list are the ME Church and the post office.

Tucked away on Willowbrook Avenue in South Bethlehem is the South Bethlehem United Methodist Church, the ME (Methodist Episcopal) church listed above. Methodism is the movement started by John and Charles Wesley. In 1729, while at Oxford University, they formed the Holy Club, where members pledged to be disciplined about their spiritual lives and to perform social service. Outsiders called them "Methodists" because of their systematic approach to their religion. The Wesleys adopted the term as a badge of honor and used it for the wider spiritual movement they sparked after their transformative religious experiences of 1738. The Episcopal part of the name stems from the organizational structure of the church in which they are governed by bishops.

The South Bethlehem United Methodist Church is seen through the winter trees. This postcard was mailed to Mrs. Peter Stoffel in 1909. *Courtesy of Michael and Sheri Frueh.*

The South Bethlehem United Methodist Church as it is today. *Courtesy of the author.*

Through the 1700s, Methodism continued to spread, coming to the colonies as early as 1760 and the Albany area as early as 1765. While South Bethlehem United Methodist Church traces its roots to 1783, Howell and Tenney report that its first building in town was constructed in 1832, near Beckers Corners (near today's Route 9W and Route 396/Bridge Street).

It was dedicated on November 20, having been built on lands of Betts Chatterton. Bradley H. Glick and John C. Green were the first preachers.

In 1845, the congregation determined to move to South Bethlehem and dismantled the church at Beckers Corners. Some of those timbers were used in the construction of the new church on land donated by Conrad Baumes. Baumes was a large property owner whose Greek Revival–style farmhouse still stands just down the road on what was then known as Church Street. The church was dedicated in February 1845 as the First Methodist Episcopal Church of Bethlehem. The pastors were Rueben Bloomer and Jason Wells. In 1886, Pastor John Buskins reported 56 families, 115 members, 97 Sabbath school pupils and 11 teachers. Also in 1886, a bell made by the Meneely Bell Company of West Troy, New York, was installed in the belfry. The church boasted electric lights in 1905, and in 1909, the stained-glass windows were added.

Today, the church continues to live its mission "to walk in God's love and to give it away." As Pastor Mark Ledbetter said during a recent Sunday service, "South Bethlehem United Methodist Church has a strong past and an incredible future."

Chapter 6

Fighting Fires in Delmar

From the September 2014 issue of Our Towne Bethlehem.

On Sunday, May 21, 1911, members of Delmar's newly inaugurated fire company responded to the ringing of the church bell and sped to a chimney fire at the home of Frank Bennett. According to a newspaper report, Assistant Chief Frank Snyder directed his men from his automobile and firefighter James Huested climbed the roof while the other firemen formed a bucket brigade to pass water up to him. The chimney fire was successfully doused. Such was Delmar's first official fire call.

The Delmar Fire Company No. 1 had been formally established six days earlier on Monday, May 15, with seventy volunteer members. Alton C. Rowe Sr. was elected chief. A proposition requesting $1,200 for fire apparatus would soon be voted on by the village. One early piece of equipment was a 1917 American LaFrance soda and acid truck on a Ford chassis. In 1925, a new Larabie Hose Cart was purchased, and the company's 1934 Mack fire truck is still seen on parade today.

Rowe served as chief until 1933. He was a community-minded Bethlehem businessman who served as Bethlehem's supervisor from 1924 to 1931. For many years, Rowe was on the board of directors of the Bethlehem Mutual Insurance Company, a company that was established in 1854 and is still in business today as the Community Mutual Insurance Company. Rowe died on September 27, 1968, after recently celebrating his 100th birthday. Roweland Avenue in Delmar is named after him.

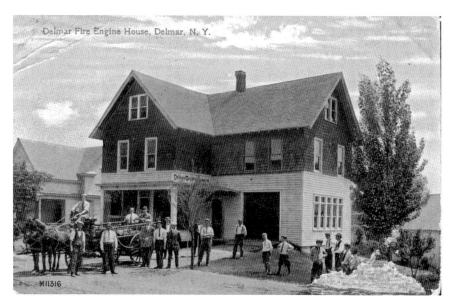

The Kenwood Avenue engine house of the Delmar Fire Company, circa 1915. *Courtesy of the Town of Bethlehem.*

In the early days of the fire company, it made use of the Kenwood Avenue engine house. In 1920, the former Adams House Hotel on Delaware Avenue was purchased to be used as the fire hall. Besides providing for the firemen and their apparatus, the new fire hall hosted clambakes, carnivals and other community events. In 1934, the company name was changed to the Delmar Fire Department. The Ladies Auxiliary was established in 1937 to advance the civic welfare in the community and promote harmony and good fellowship among its members and cooperation with the Delmar Fire Department.

Change was in the air in 1950, when the Town of Bethlehem agreed to purchase the white-pillared Adams House building and convert it for town offices (town hall occupied the building until 1980). Contracts for the new fire hall were let in November 1950 by the board of fire commissioners of the Delmar Fire District for construction immediately adjacent to the old building. The front door would face Adams Street.

The fire house, now known as Station One, has continued to be improved and enlarged over the years, although Chief Dan Ryan Jr. notes that the bays are still a tight fit for modern fire equipment. The reconfigured building now has its main façade on Nathaniel Boulevard with six bays and a memorial flagpole. Station Two on Feura Bush Road was added in 1970.

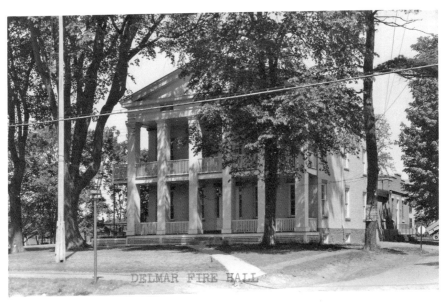

The Delmar Fire Hall, circa 1950. *Courtesy of the Town of Bethlehem.*

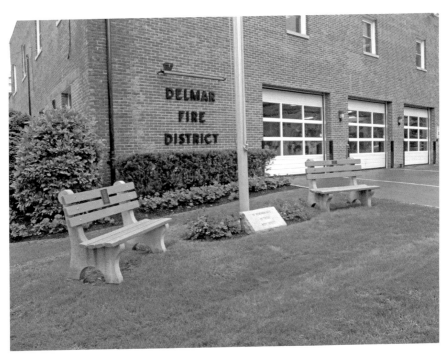

A modern view of the Delmar Fire Department's main entrance on Nathaniel Boulevard features the memorial flagpole. *Courtesy of the author.*

Today, the Delmar Fire Department continues strong with sixty-five volunteer members. The year 2013 saw the department responding to 322 fire calls. Delmar's rescue squad was established in 1939 as part of the Delmar Fire Department. Emergency medical services were consolidated with the creation of the Delmar-Bethlehem EMS in 2013.

Part II

COMMERCE

Chapter 7

TOO STUBBORN TO QUIT

Lehmann's Garage, 1913–2013

A version of this article was originally published in the
April 2013 Our Towne Bethlehem.

Bert Lehmann says he is "too stubborn to quit" his Selkirk business, which started as a blacksmith shop founded by his great-grandfather Jacob Albert Lehmann in 1913. Under the helm of Bert's grandfather Albert Jacob Lehmann, the shop transitioned to auto repair in the 1920s.

Bert's building on Maple Avenue is filled with history. His modern-day equipment shares space with the anvil his grandfather used to shape horseshoes. A gleaming Mustang automobile awaits work adjacent to where the horses had their hooves shod. Family lore says the schoolhouse clock ticking on the wall came from a pool hall in Ravena and was given to Jacob when the shop opened. Even the old, worn vice clamp on the scarred workbench tells the story of four generations of repair work.

Jacob Albert Lehmann was born about 1861 in Germany and immigrated here when he was about sixteen years old. He lived and worked in the Schodack area, marrying his wife, Ella Baker, there. They moved to Cedar Hill, where Jacob worked for a blacksmith. This Cedar Hill blacksmith was probably Frank Mathusa, whose business included horseshoeing and general blacksmithing plus carriage, wagon and sleigh building. In 1913, Lehmann purchased a former cooper's shop across from the railroad station in the hamlet of Selkirk and opened business for himself.

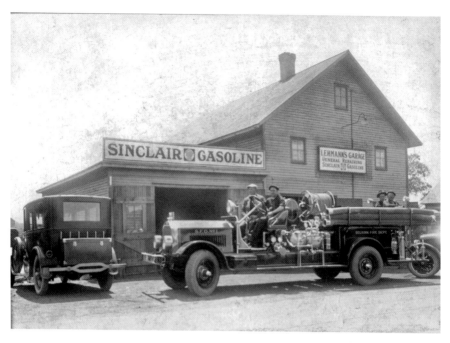

A Selkirk Fire Department Engine is in front of Lehmann's Garage, circa 1930. *Courtesy of the Bethlehem Historical Association.*

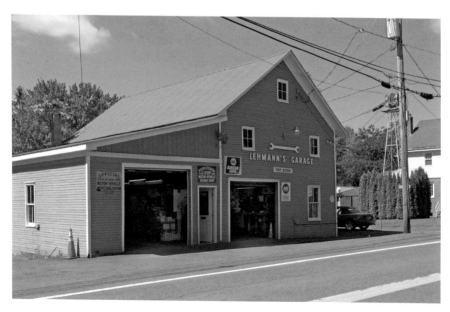

A modern view of Lehmann's Garage. *Courtesy of the author.*

Both coopers and blacksmiths were important parts of rural Bethlehem. A cooper makes wooden casks or barrels. These essential storage and shipping containers came in different sizes and could hold a wide variety of goods—everything from flour and wine to shoes and books. Blacksmiths worked forging iron and steel into tools, cooking utensils, horseshoes and more.

When Lehmann opened his shop, the hamlet of Selkirk was small, focusing mainly on nearby farms. Next door was Vrooman's Grocery Store, which included the post office. Selkirk's station of the West Shore Railroad was across the street. The District No. 2 schoolhouse was just down the road. The hamlet continued to grow, especially with the opening of the Selkirk Rail Yards in 1924. The Selkirk Fire Department built its firehouse next door to Lehmann's in 1928.

During the 1920s, Albert Jacob Lehmann, son of Jacob Albert, recognized the ascendance of automobile transportation and transitioned the blacksmith shop to auto repair and gasoline sales. His son and grandson, both Albert Jacobs, continued the work with autos. That grandson, the Bert Lehmann mentioned above, kindly named one of his sons Jacob Albert to interrupt the three-generation string of Albert Jacobs. Bert Lehmann reports that both of his sons worked in the shop as teenagers, with one going into auto body repair, although not in his father's shop. Today, Lehmann's Garage remains a mainstay of the hamlet of Selkirk.

Chapter 8

ALWAYS COOL AND COMFORTABLE

The Delmar Theatre

Originally published in the August 2013 issue of Our Towne Bethlehem.

Always Cool and Comfortable" is a slogan we all can relate to in the hazy, hot days of August. Such was Conery's Delmar Theatre advertising in July 1938. On Monday the eleventh, one could enjoy the musical comedy *Josette*, starring the comedic talents of Dom Ameche and Robert Young. This black-and-white film was preceded by color cartoons and a "Floyd Gibbons Thrill." Gibbons was a thrill-seeking news correspondent during World War I who often wrote about his exploits. In the 1920s and '30s, he was a famous radio pundit and narrator of newsreels. Gibbons publicized his *True Adventures* radio show as "Thrills and Chills and All True."

The Jarvis brothers opened the Delmar Theatre in early April 1929. The brick building featured a storefront on either side of the main entrance. The *Altamont Enterprise* of May 10, 1929, declared that fine programs were being shown there: "Nowhere outside the cities can one enjoy the best in so pleasant surroundings as at the Delmar Theatre, and it can be reached so easily over good roads and away from crowded city traffic that it is a pleasure to motor there."

Advertising in 1932 promised "Big Programs—Best Sound." In 1933, the Delmar Theatre offered itself as the "home of better photoplays"; this was upgraded in 1934 to "home of superior photoplays." Admission was twenty-five cents for adults and ten cents for children.

In the late 1930s, the Jarvises leased the theater to Mitchel Conery of Ravena. Conery was a local theater magnate whose cinemas included ones

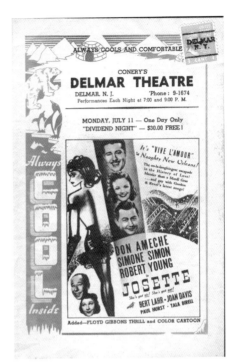

Right: A Delmar Theatre Program from July 1938 promising to be "Always cool inside." *Courtesy of the Town of Bethlehem.*

Below: The Delmar Theatre near the time of its construction in 1929. *Courtesy of the Town of Bethlehem.*

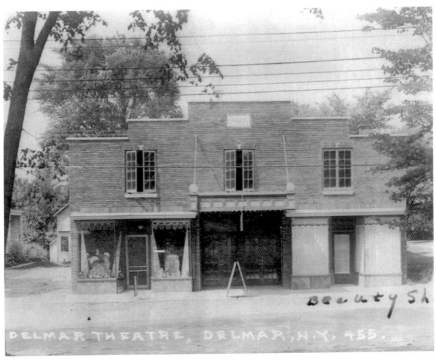

in Ravena, Schoharie, Athens, Hensonville and Delmar. In Delmar, he ran a Kiddie Klub, advertising a pie-eating contest before the show. A June 1938 matinee featured the grand opening of the "new delicious popcorn machine with a free balloon pet with every box of this delicious food," as reported in the *Altamont Enterprise*.

By the 1940s and '50s, the theater was back in the hands of the Jarvis family, with Mrs. Joseph Jarvis being the primary proprietor. The 1957 Tri-Village Directory lists Mrs. Jarvis as the owner of "Your Community Theatre" showing the "Cream of Hollywood Presentations." The theater closed in early 1959 and is not listed in the 1959 Tri-Village Directory, last advertising in the *Spotlight* in the January 8, 1959 issue.

The Delaware Avenue building is today home to the 333 Café and several other businesses. Some may remember the days when Vet's Body Shop and Garage occupied the space. Libby Thomas of the 333 Café reports that nothing remains to indicate a theater was ever in the building, not even in the depths of the basement.

Chapter 9

THE SLINGERLAND PRINTING COMPANY

From the March 2013 issue of Our Towne Bethlehem.

Many are interested in the large building complex that looms over the intersection of New Scotland Road and Kenwood Avenue in the hamlet of Slingerlands. Just visible on the brick addition to the right are the painted letters LITHOGR. They date from the days when this was the bustling Slingerland Printing Company and its brick façade was inscribed with advertising for printers, rulers, binders and lithographers.

Cornelius H. Slingerland established the Slingerland Printing Company in 1879. Conveniently located near the D&H Railroad line, the company specialized in printing for the railroad, including timetables and other railroad forms. Posters, election forms and items like paper, envelopes and twine rounded out the business. Factory work has its dangers. In May 1909, the *Altamont Enterprise* reported that employee Charles Pierson, whose face is circled in the accompanying picture, "ran a nail in his hand while at work at the printing office inflicting a painful wound."

Slingerland married Nellie Mattice in 1882 and soon built a stately Victorian-style home close to the factory. It still stands at the end of today's Mullens Road and remains in the family. Cornelius and Nellie's daughter Mary, her husband Clarence Mullens and general manager Andrew Couse became owners of the property after Slingerland's death in 1914.

In 1935, the company was sold to the Burland Printing Company, which kept the Slingerland name. It reportedly purchased the company for more

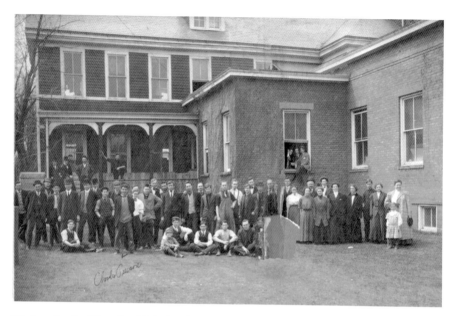

Workers for the Slingerland Printing Company gather for a portrait about 1909. Employee Charles Pierson is circled. *Courtesy of the Town of Bethlehem.*

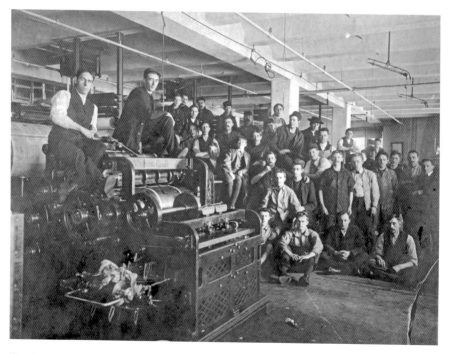

Employees gather around a cylindrical printing press believed to be at the Slingerland Printing Company. *Courtesy of Kathy Volo.*

than $100,000 and intended $250,000 in improvements, which would include many new linotype machines and cylinder presses. Employment was projected to increase from about sixty to more than two hundred employees. Burland focused on New York State printing contracts. By 1941, the building was no longer being used for printing, and it was sold to Robert and Arthur Zautner in 1945. They converted the building to apartments, a use the building still enjoys today after extensive renovations in 2007.

SLINGERLAND PRINTING COMPANY REVISITED: A NATIONAL EXPRESS COMPANY RECEIPT BOOK

Originally composed in April 2013, this article can also be found on the Historian's Webpage at the Town of Bethlehem's website.

In the fall of 2012, Jane Tollman was kind enough to invite me into her home in search of Slingerland family history. You see, Jane's husband was the great-grandson of Cornelius H. Slingerland, founder of the Slingerland Printing Company. I was curious what I would find that would add to the story of the family and the business whose building remains a prominent landmark at the corner of New Scotland Road and Kenwood Avenue.

With the help of a flashlight, the dusty confines of Jane's Victorian attic yielded a dull and dog-eared receipt book from the National Express Company. It was near a moldering pile of William M. Patton's *Paper and Press Magazine*. This little book gave several intriguing insights into life in the hamlet of Slingerlands in the late 1880s.

Each page of the book is a preprinted form filled in by the express agent. For example, one page says that on July 31, 1886, the National Express Company "Received from *C.H. Slingerland 1 package of money* sealed and said to contain *eight dollars*. Addressed *Farmer Little and Co 63 Beekman Street, N.Y. City, NY*" (italics are handwritten).

The majority of the forms are to various suppliers of the printing company. They include the above-mentioned Farmer Little, a type foundry; J.E. Linde Paper Company of New York City; and Moran & Willcox of Middletown, New York, a provider of imposing and ink stones. Intriguingly, there is also a series of large payments (thirty-five dollars, sixty-one dollars and sixty-four dollars) to the New York Steam Power Co., which is a builder of "superior steam engines and boilers." This description comes from

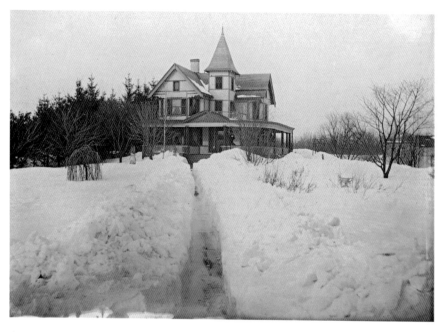

Cornelius and Nellie Slingerland's Victorian-style home is seen here about 1920. *Courtesy of Jane Tollman.*

company letterhead. It appears that in 1886, Slingerland was making capital improvement to the power supply of his printing plant.

Two other questions arise: Why didn't he simply write a check and why didn't he just put the check in the mail?

Perhaps he could have written a check. Demand deposit accounts were becoming widespread in the 1880s, and Albany certainly had its share of banks, including the Home Savings Bank of Albany and the Albany Savings Bank. As far as I know, Bethlehem did not have a bank until the Bank of Bethlehem was established in 1927. So, I am left wondering about how the banking system worked in that era. Could he write a check drawn on an Albany bank and could it be cashed at a New York City bank? Was it simpler and more direct just to send a package of cash? More research is necessary to answer these questions. What is for sure is that between April 1, 1886, and November 1887, Slingerland sent over fifty individual packages of money via the National Express Company.

While the U.S. Postal Service has been around since 1775 and the first postage stamp was published in 1847, domestic parcel post was not established until 1913. As an aside, you might be curious to know that while city dwellers

had free home delivery starting in 1863, rural free delivery (RFD) began in the 1890s. The Slingerlands RFD route made its first deliveries on February 1, 1902. The first postmaster of Slingerlands, back when the hamlet was still called Normanskill, was William Henry Slingerland, Cornelius's great-uncle. He was postmaster from 1852 until about 1872.

The express service business grew out of the old stagecoach lines, with people entrusting their packages and parcels to the stagecoach driver. Parcels often moved by private hands. Friends and associates known to be traveling (say from Slingerlands to New York) would be asked to take along and see delivered a letter or package. Steamboats and railroads were soon added to the mix of travel modes.

The National Express Company has its roots in two companies. Pullen, Virgil & Co. ran an express service in northern New York and Canada in the early 1840s that included stage, steamship and railroads. The 1854 opening of the Albany Northern Railroad led to the establishment of Johnson & Co., which focused on moving packages from Albany to Rutland, Vermont, including Saratoga, with plans to expand to Canada. These two companies combined in 1855 to form the National Express Company.

For Slingerland, it probably came down to speed and simplicity. Like senders today deciding between the USPS or Fedex or UPS, Slingerland made the decision to use National Express for his business packages. A walk across the railroad track brought him to the Slingerlands Station and the National Express office with its promise to forward "coin, bank notes, valuables and merchandise with safety and dispatch" (as quoted from the front cover of the receipt book).

Alexander Lovett Stimson's *History of the Express Business: Including the Origin of the Railway System* provides a fascinating history of the express services. The book was published in 1881. It includes this helpful hint about shipping COD (cash on delivery): "In sending a bill C.O.D., always send the goods with the bill, otherwise the cabalistic letters C.O.D. on a package are more ornamental than useful. Never send fresh fish, lobsters, or ice cream C.O.D., unless you are prepared to receive and pay charges on the unpleasant remains in case they are returned for non-payment of bill."

This simple little book belonging to a Bethlehem family living and working in 1880s Slingerlands led me on to the history of railroads and the post office, banking and check writing. It provides a glimpse into how a local business fit into the wider U.S. economy with its networks of banking, transportation and commerce.

Chapter 10

THE HOME LAWN HOTEL

Originally published in Our Towne Bethlehem *in October 2013.*

One hundred years ago, Bethlehem had numerous hotels. Snyder Hill, Hurstville, Dunn's, Zelie's, Klemp's, Hinckel's and Abbey were all familiar names. In 1913, collector of taxes James W. Beeten published his schedule for when he would be at these places in order to receive taxes. As a bonus, on three days supervisor Charles D. Niver would also be in attendance.

Numerous hotels were a necessity back in the days when travel was much more arduous than it is today. Farmers traveling to market in Albany could only go so far in a day; the same was true for teams hauling stone from the Helderbergs and those taking a more leisurely tour of upstate New York. While the advent of the toll roads, plank roads and even the railroads helped, travel and the movement of goods still often necessitated an overnight stay. In addition, the local hotel was often the local tavern and gathering place.

The Zelie's mentioned in the list above is the former Home Lawn Hotel in Slingerlands. Located on New Scotland Road near the railroad overpass, the building today is a private residence. Rufus Zelie operated the Home Lawn Hotel for twenty years from 1897 to his death in 1917. He succeeded proprietor Thomas Richie after managing the Island Park clubhouse for five years. Zelie hosted banquets and dances, political gatherings, railroad executive meetings and social clubs, as well as serving as a destination for automobile and sleighing parties from Albany.

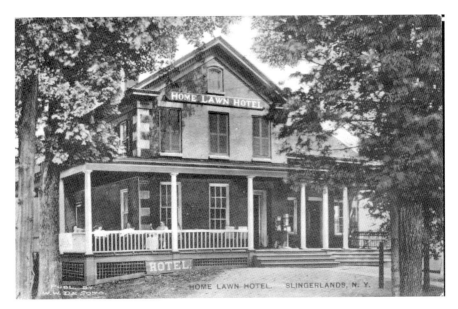

The Home Lawn Hotel graces this circa 1910 postcard. *Courtesy of Janet Vine.*

Local dry laws, New York State's Raines Liquor Law (1896), the Eighteenth Amendment to the U.S. Constitution and the Volstead Act ushered in the Prohibition era (1920–33) and the eventual closing of the Home Lawn Hotel. The death of local resident Dr. Persons by a drunk driver in 1922 led to a "mass meeting" of residents of the village, who declared the hotel a public nuisance and called for its closure. The *Albany Evening Journal* of May 16, 1922, reported, "For two years or more the Home Lawn Hotel has been obnoxious to the respectable citizens of Slingerlands and it is said many a joy riding party became drunk there." Judge Cooper agreed, and proprietor Albert Kientz was ordered to close the hotel.

Today, a sweeping circular drive leads to the welcoming front door and patio of this imposing brick edifice. The small wing to the right with its eyebrow windows is the original home from the early 1800s. The central block with its Greek Revival pediment and details was added in the 1850s, with the large three-story hotel wing to the rear being added on in the late 1800s.

If you are curious, Snyder Hill is located off Martin Drive, Feura Bush. Hurstville was on New Scotland Road near Whitehall Road. Hinckel's was in Normansville (on the Albany side today near the lower bridge). The Abbey was located on River Road near the Glenmont Road intersection. Klemp's and Dunn's remain mysteries.

ADDENDUM

Not long after writing about the Home Lawn Hotel, I was at a meeting of the Bethlehem Historical Association when a gentleman walked up to me and handed me a folder containing some old documents. One of those documents was a bill of sale between Norman Crum and William M. Dunn regarding the Delmar Hotel dated May 31, 1910. The Dunn's hotel mentioned above is surely the former Delmar Hotel.

Here's the list of items sold:

> *I, Norman Crum,…do grant and convey…all my right, title and interest of, in and to the business conducted by me at the village of Delmar aforesaid in the hotel known as the "Delmar Hotel"; and all the stock, furniture, pool tables, cash registers, chairs, tables, stoves, and all bar room fixtures, excepting front and back bar; also all furniture in said hotel and rooms thereof, excepting piano and stove in parlor first floor, and bed and furnishings in upper front, side board and extension table in dining room, safe in upper floor; Also conveying to said party of the second part all stored ice, ice bars, picks, barrows and tools in ice house, two wagons, one cutter, one set of eight double harnesses, pitted picks, shovels and rakes, all lawn swings, settees as now in use in and about said Delmar Hotel except as stated.*

Can't you imagine a comfortable hotel with pool-playing patrons enjoying a game while piano music plays in the background, perhaps sipping an iced beverage from one of the two bars? Even the outdoor space sounds inviting with its lawn swings and settees for relaxing.

Serendipity like this old document turning up just when I was wondering about Dunn's is one of the many reasons work in local history is so rewarding. Now, if only something about Klemp's would turn up.

Chapter 11

THE BANK OF BETHLEHEM BUILDING

Originally published in the December 2014 issue of Our Towne Bethlehem.

The Bank of Bethlehem was prominent in the Delmar community for nine years. Chartered by New York State in September 1927, the bank issued five hundred shares at $150 per share. They promptly sold out. Horace B. Casey was president of the bank along with directors LeRoy Arnold, Daniel A. Bennett, William Gillespie, John Herber, Thomas Holmes, Samuel Nuttal and Edward J. Slingerland.

Shortly after organizing, plans for the bank building were created by architect Galen H. Nichols, and construction was begun by the C.V. Soule Company of Delmar. Due to mild winter weather, construction was completed quickly, and the bank opened for business on Monday, March 26, 1928. The cashier was Stanley C. Cornell, teller Earl Hevenog, stenographer Lucille A. Robinson and janitor David Keefe.

During 1929 and '30, the bank ran a series of charming historic themed ads in the *Altamont Enterprise*. One featured a mechanized Tewksbury Rocking Cradle asking potential customers, "Are you awake to the marked influence a Time Deposit account has upon the future of your child? One dollar opens an account at the Bank of Bethlehem." Other ads featured old-fashioned ice skating, spinning wheels and George Washington's horse-drawn coach.

Annually, the bank published a statement of condition listing resources (approaching $1 million in 1936) and liabilities. This attested to the

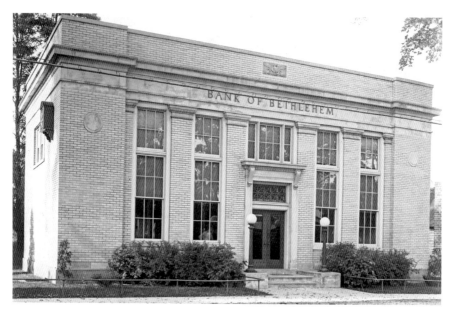

The Bank of Bethlehem, circa 1928. Note the alarm box on the left side of the building. *Courtesy of the Town of Bethlehem.*

bank's stability and was important reassurance during these Depression-era years. Recall that the great crash happened on September 4, 1929.

The Bank of Bethlehem was acquired by the National Commercial Bank & Trust Company in 1937. Stockholders received $225 per share. Henry Keelan, cashier, became the branch manager. National Commercial traces its history back to 1825, when it was chartered by Governor Dewitt Clinton as the Commercial Bank of Albany. It reorganized in 1865 as the National Commercial Bank of Albany. National Commercial adopted the name Key Bank in 1979.

The sturdy brick building on Delaware Avenue is now home to a branch of TD Bank. When it was built, the exterior included large two-story windows between column-like pilasters with a heavy cornice over the doorway. While much of this has changed, the carved eagle plaque centered near the roofline has stood watch over the building since the beginning. The early bank included a prominent exterior box that was probably part of the bank's burglar alarm system. Such alarm bells could be triggered from a switch inside the vault and at the teller windows. The loud alarm could wake the whole neighborhood.

Walking inside today, one sees modern banking fixtures with the expected teller counter, vault and desks. One needs to use imagination to guess at the

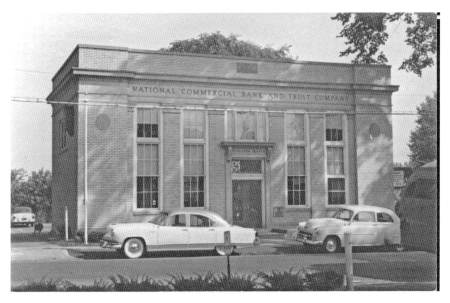

The National Commercial Bank, circa 1950. *Courtesy of the Town of Bethlehem.*

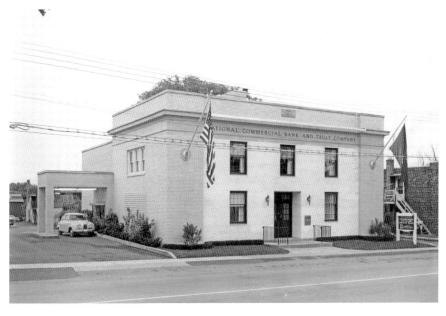

By 1963, when this photo was taken, the bank building's exterior had been substantially changed. Note the addition of a drive-through window. *Courtesy of the Town of Bethlehem.*

decorative woodwork and high tin ceilings that probably existed in 1928. Long gone is the alcove room for female patrons with its writing facility and telephone. Gone is the upstairs director's room (now a kitchen) and the downstairs ballroom (now a storage room, although the 1960s-era chandeliers still hang there). Hidden behind the drop ceiling is the walkway from which guards used to observe the main banking lobby.

Even with all the changes, the newspaper description from the *Albany Evening News* dated March 24, 1928, still holds true: "The building is of classic design and fully equipped for banking purposes."

THE ICE INDUSTRY AND
HENRY HUDSON PARK

A version of this article was published in November 2014 in
Our Towne Bethlehem.

Traveling down Barent Winne Road, on the way to Henry Hudson Town Park, at the top of the hill that goes to the river, one notices the elegant Second Empire–style home of George and Ursula Best. When it was built in the 1880s, the home's central tower would have had a sweeping view of the Hudson River and the ice warehouses that Best built. Nowadays, most traces of the Hudson River ice trade are gone, yet as early as 1850, ice was a major U.S. industry. Having ice in the summertime became as essential as having coal in the wintertime.

In 1879, the year after George N. Best bought his Cedar Hill property, the U.S. ice harvest was estimated at eight million tons. Melting during storage and shipment reduced to five million tons the amount that reached consumers. By 1886, the annual U.S. harvest figure was twenty-five million tons. There were at least 135 ice warehouses along the Hudson River from New York to Albany, with Bethlehem's shoreline being well represented. Besides George N. Best, other local names included Dettinger, Tilly Littlefield, Wheeler, Baker and Schifferdecker. In view across the river would have been ice warehouses on Staats Island and Campbell Island.

The March 1905 issue of the *Cold Storage and Ice Trade Journal* notes that both of George N. Best's warehouses were at capacity: 38,000 tons at Cedar

The dramatic architecture of George and Ursula Best's Cedar Hill home is seen in a modern photograph. *Courtesy of the author.*

Hill and 35,300 tons at Campbell Island. The Hudson River harvest below Albany, with 151 icehouses reporting, was 3,313,371 tons of ice.

Best and his Cedar Hill Ice Company had a New York City office with dockage for the ice barges coming down the river. Son Harvey Best maintained those operations. Harvey tragically died of typhoid fever at the age of twenty-six in Hoboken, New Jersey. His wife, Amanda Clum, eventually moved in with her in-laws at Cedar Hill.

Shortly after George Best died in 1917, Ursula sold the Cedar Hill property to ice businessman Frederick Schifferdecker. The icehouse seen from Best's house burned to the ground in 1923. And indeed, the whole huge ice industry was burning out about this time with the advent of mechanical refrigeration. Reliable artificial ice soon replaced natural ice with its dependency on the variables of Mother Nature.

Eventually, the land along the Hudson River where Best's icehouse was became Bethlehem's Riverfront Park in 1968, after passing through the hands of several owners and various parcels, including a portion that belonged to the Tri-City Yacht Club. The parcel with the Bests' home remains private property.

At the August 13, 1975 regular meeting of the Bethlehem Town Board, a resolution was adopted to name the riverfront park Henry Hudson Park at Cedar Hill. Hudson is the English explorer who sailed for the Dutch in 1609 aboard the *Half Moon*. The formal dedication of the park on September 19, 1975, marked the beginning of Bethlehem's yearlong bicentennial celebration, a part of the greater United States bicentennial fever that was sweeping the nation in 1975 and 1976.

Today, the park remains a vital place. While nature abounds with regular sightings of bald eagles and great blue herons, man-made amenities include a boat ramp, fishing docks, a picnic pavilion, a playground and a baseball field.

CUTTING ICE

The winter ice harvest was a time for Bethlehem farmers to earn extra income. While waiting for the ice to reach the ideal thickness, horse-drawn plows kept it free of snow. Once the ice reached a thickness of at least fourteen to sixteen inches, the first step was to mark off the ice field in a grid pattern. Horses then pulled cutters along the lines to a depth of about twelve inches. Workers would then bar off the individual cakes and float them on

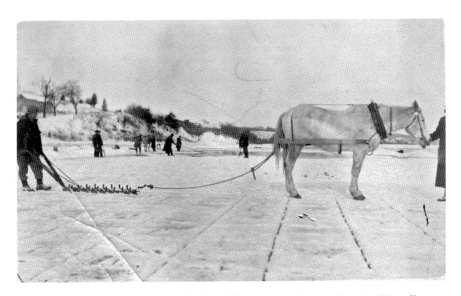

Men and horses work on the frozen Hudson River to score the ice before breaking off individual cakes. *Courtesy of the Town of Bethlehem.*

channels to the ice warehouse. The preferred size for the New York market was twenty-two inches by thirty-two inches.

The cakes of ice were sent up the ramp and lifted to the top of the warehouse. Ice was carefully packed in straw or sawdust to help it endure the heat of spring and summer. As needed, ice was loaded on steamers for the trip downriver to New York City or upriver to Albany.

In Bethlehem, ice was also harvested from the Normanskill by damming the creek to create ponds. Remains of Pappalau's icehouse can be seen at Albany's Norman's Kill Farm Park. This area was part of the town of Bethlehem until 1910. When the Hudson River became too unclean for people's ice cubes, water from the Vlomankill was used to create ponds for the ice harvest. These were located where the baseball field is at Henry Hudson Park.

Winne's Dock

Just to the north of today's Henry Hudson Park, and conveniently located near George Best's icehouse, was the commercial venture of Barent Winne's dock. Winne began here as early as 1860 shipping out local products such as lumber, hay and oats and receiving goods like coal, furniture and hardware. He also ran a general store and warehouse facility. Today, all that remains is a stub of the wharf that once jutted into the Hudson River and the elegant brick home he built for his family. In the park, north of the modern boat launch, other evidence of commercial activity is apparent in the remains of an old scow or barge visible at low tide and various cement footings and metal pieces along the shoreline.

BETHLEHEM BLACKSMITHS

John Martin and David Baxter

A version of this article was published in the July 2015 issue of Our Towne Bethlehem.

Blacksmiths forge wrought iron and steel into tools, cooking utensils, horseshoes and much more. They can repair farm equipment, shoe horses and make nails and lengths of chain. If it has to do with iron or steel, the blacksmith is your go-to person. A whitesmith, on the other hand, is someone who works tin. Both would be considered metalsmiths.

Through the years, Bethlehem has had many independent blacksmiths in support of our rural, agricultural economy. Hamilton Child's 1870 *Gazetteer of Albany County* lists nine blacksmiths in the town of Bethlehem, including John Martin of Bethlehem Center. Martin is listed as a wagon maker and blacksmith. Just about everyone in the directory for Bethlehem is listed as a farmer, often in combination with another occupation: Soap maker and farmer. Physician and farmer. Milk dealer and farmer. Carpenter and joiner and farmer. Christopher Trager, also of Bethlehem Center, was a blacksmith and farmer, as were Edward Cloeweny and Daniel Caley. Henry Arnold, James Carpenter, Charles Kinny, Robert McDowell and Joseph Moore were the other blacksmiths.

John Martin and his wife, Elizabeth Rawer, were both born in Germany. By the 1870 U.S. census, they were established in Bethlehem Center near today's Price Chopper and Farm Family Insurance on Route 9W. John, age thirty-seven, was blacksmithing, and Elizabeth, age

thirty-one, was keeping house. They had seven children, including son John, age thirteen, who would go on to be a blacksmith. Also in the household was Fred Garehiner, age twenty-one, a blacksmith. Next door were A. Vandenburg and his wife, Polly, and son Levi. Vandenburg was a wheelwright, which fit nicely with the gazetteer listing mentioned above. John (1833–1890) and Elizabeth (1839–1902) are buried down the road in Elmwood Cemetery. John the younger remained single and continued blacksmithing in Bethlehem Center at least through the 1925 New York census, when he was sixty-eight and still listed as a blacksmith. By that time, he was living with his brother-in-law William Comstock on the Bethlehem Stone Road, another name for Route 9W.

David Baxter was another blacksmith working in Bethlehem who followed in his father's footsteps. His father, Henry Cox Baxter (1833–1914), was born in England. He came with his family to the United States and settled in the town of Knox. By the 1892 New York census, Henry and his wife, Elizabeth Van Auken, had settled in Adams Station (today's Delmar). Henry continued to make a living blacksmithing while they raised their six children. Son David was born in 1869. David married Anna Marie Adams on November 6, 1895. Anna was the granddaughter of Nathaniel Adams, proprietor of the Adams House Hotel and Adamsville/Adams Station namesake.

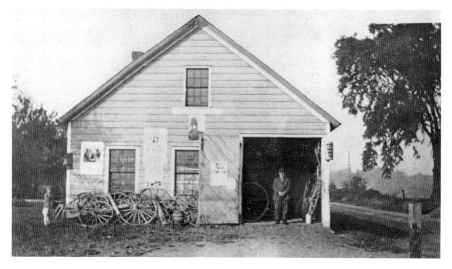

Blacksmith John Martin stands in the side door of his shop in 1917. Notice the abundance of wagon wheels. *Courtesy of Connie Tilroe.*

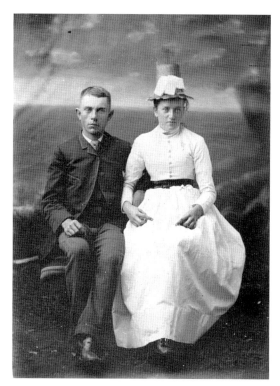

Right: David Baxter and Anna Marie Adams, circa 1895. *Courtesy of Barbara Castle.*

Below: Blacksmith David Baxter (on left with hand on horse) in front of his Normansville shop. Notice the large horseshoe hanging by the blacksmith sign. *Courtesy of Barbara Castle.*

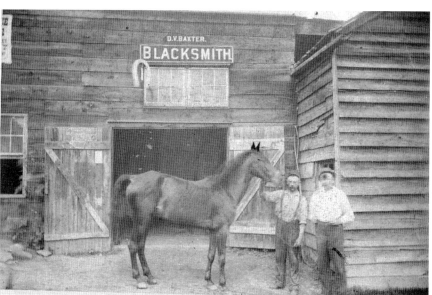

Shortly after their marriage, Anna and David set up their own household in Normansville. Through the 1920 census, David was listed as a blacksmith in Normansville. By 1930, when he was sixty, his occupation had changed to laborer for the state. Anna and David had one son named Malcolm.

THE BLACKSMITH SHOP AT NORMAN'S KILL FARM PARK

One of the pleasures of being town historian is the chance to lead history hikes. The one through the hamlet of Normansville often includes a visit to a working blacksmith shop.

Stepping into the blacksmith shop at the Norman's Kill Farm Park, the first things I notice are the tools, everywhere hand-forged tools; the smell, the oily smell of burning coal; and Jim Moran, tall and lanky, standing beside the forge ready to show our group a little bit about blacksmithing. Lighting up newspaper, adding a scoop of coal and adjusting the airflow with the bellows, Jim gets the forge hot. He picks up a bit of steel (recycled from one

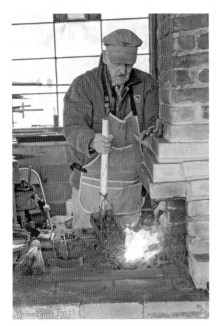

Blacksmith Jim Moran adds coal to the fire at the forge at the Norman's Kill Farm Park. *Courtesy of Michael Joyce.*

of those pesky lawn signs that show up in abundance during election season) and demonstrates how the application of heat turns the steel pliable. Using hammer and anvil, he can then shape it as desired. Such is the basic premise of the blacksmith.

Jim Moran has been blacksmithing since 1972, enjoying the process of taking a raw material, like iron and steel, and crafting it into something. He can use hammer and anvil, heat and force, to create all manner of useful and decorative items, from hammers and tongs to nails and hooks. But his favorite work is repairing things and making them functional again.

The blacksmith shop at the Norman's Kill Farm Park was part of the Stevens farm. It was set up to handle maintenance work for the

farm and included a brick forge for blacksmithing. For a large farm like the Stevens property, which went on to become the hub of the Norman's Kill Farm Dairy, it made sense to have a blacksmith on site. J.M. Drew wrote *Farm Blacksmithing* in 1910 and advocated for farmers to do their own basic blacksmithing. Drew argues that the time saved by making one's own repairs is more important than any cash saved. "What farmer has not often been obliged, by some slight breakage, to go to the town or village shop, perhaps several miles away, and there find that he must wait for several horses to be shod before his little job…could be attended to by the blacksmith."

The Norman's Kill Farm blacksmith building dates from the 1830s. The farm's maintenance shop and blacksmith were in the front section, and ice storage was in the back. Over the years, the forge fell into disrepair. In 2007, it was restored using the designs of Patrick Grossi. Grossi, himself the son of a blacksmith, was the lead blacksmith at the Farmer's Museum in Cooperstown. His design was built by a city of Albany mason. Sadly, Grossi died just two months shy of the opening of the forge. Jim Moran has led blacksmith duties ever since and hosts regular meetings of the Capital District Blacksmiths Association, as well as countless presentations for schoolchildren.

The Norman's Kill Farm Park, owned by the City of Albany since 1980, hosts several hundred elementary-age students in the spring for farm tours and blacksmithing demonstrations. The park boasts hiking trails, a dog park and community gardens. It is the home of the Albany police horses and mounted patrol. Also on the property and not to be missed is the historic Whipple bowstring truss bridge. Moved here in 1899 to carry the farm road over a steep gorge, it is one of the earliest surviving iron bridges in the United States. It was constructed in 1867 in Syracuse, New York, to span the Erie Canal.

One should note that the park was located in the town of Bethlehem until 1910, when the area was annexed by the City of Albany.

Chapter 14

ADAMSVILLE AND THE DELMAR FOUR CORNERS

A version of this article appeared in the March 2014 Our Towne Bethlehem. *It has been updated with information about Nathaniel Adams.*

THE ADAMS HOUSE

In the 1830s, the crossroads that would become the Delmar Four Corners was a quiet, rural spot on the Delaware Turnpike. Burr's 1829 map indicates one could head southwest out of Albany to the rural metropolises of New Scotland or Rensselaerville. About this time, Nathaniel Adams was the proprietor of the popular Marble Pillar in Albany, catering to a well-to-do clientele.

As late as 1837, Adams was advertising in the *Albany Evening Journal* his "splendid and fashionable resort...the Marble Pillar...given a new polish... besides his daily ordinary, Mr. A. has made arrangements for an early and full supply of first rate oysters, lobsters, fish and every delicacy."

Adams saw opportunity in the continued development of stagecoach service along the Delaware Turnpike and picked his spot in Bethlehem. On February 10, 1834, he purchased 92 acres from Dexter Brown that included the location on the turnpike where he would build his hotel. In the years to come, he would go on to buy more parcels in the Four Corners area and Normansville, totaling 515 acres. Adams built his Greek Revival–style Adams House in 1838. It was a stagecoach inn and local gathering spot, becoming the nexus of the community soon to be known as Adamsville.

The Adams House is seen here about 1900. Note the dirt road that is Delaware Avenue in the foreground, the carriage sheds on the left and the old barn on the right. *Courtesy of the Town of Bethlehem.*

On the personal side, Adams (1802–1892) was born in Connecticut to Simeon and Ester Adams. He married Rhogenia Baumes (1806–1861) on September 4, 1825. They had a number of children, but surprisingly, the usual sources are a bit murky about exactly how many they had. The 1850 federal census lists George (twenty-one), John (fifteen), Martha (eleven) and William (nine), while the 1855 New York census lists John (twenty), Martha (sixteen), William (thirteen) and Delia (four). All of this makes sense until a newspaper clipping regarding Nathaniel's will turned up. George, John, Martha and William are mentioned plus James and Ann, but no Delia.

Besides his career as a hotelier, Nathaniel was the first postmaster in Adamsville, appointed in 1840. He was also a noted horticulturalist. In 1842, the Adamses donated land for the Delmar Reformed Church, and in 1871, the First United Methodist Church of Delmar purchased a plot from Adams for $500. He and his family left a lasting mark on the hamlet. For example, John continued to run the Adams House until the early 1900s. (The building was sold to the Delmar Fire Company in 1920.) George was Bethlehem's

Husband John Adams (son of Nathaniel Adams) and wife Louisa Haswell. John and Louisa were married on May 1, 1858, and had two daughters, Jessie and Grace. *Courtesy of Sandra and John Papson.*

supervisor from 1867 to 1870. He donated the land on Adams Street for the original Bethlehem Public Library building. William served during the Civil War with Company F of the Seventh New York Heavy Artillery.

THE DELMAR FOUR CORNERS

The crossroads of Delaware and Kenwood Avenues have been a focal point of Delmar since the days when it was still known as Adamsville. The area has seen many changes over the years, from the dirt roads of the horse and buggy era to the passenger cars of the railroad commuters; from the macadam roads and Model Ts of the early twentieth century to today's high-tech automobiles and buses. Businesses and buildings have come and gone, but the Four Corners remains a community center.

The late 1920s and early '30s were a bustling time for the Four Corners. The completion of the viaduct over the Normanskill in 1928 made travel between Albany and the Delmar/Elsmere area easier. While still catering to locals, Delmar businessmen saw the opportunity to lure Albanians out to the suburbs and began re-envisioning the Four Corners area. Substantial

brick buildings like the Bank of Bethlehem, Delmar Theatre, the Paddock Building and the Wood Building, all sizable commercial buildings, were constructed during this era. It was also about this time that the name Delmar Four Corners began appearing in advertising.

The Paddock family certainly had an impact. As early as 1900, the family had a general store located in a wood-frame building at the corner of today's Delaware Avenue and Paddock Place. It was demolished in 1985 soon after the Four Corners Luncheonette moved out. Today, the lot is part of the Swifty's property. The Paddock Building, the two-story brick building that stands along Kenwood Avenue, is a business block built in 1928 with room for stores on the first floor and apartments above.

One prominent family member was Howard P. Paddock, a real estate developer, insurance man and all-around Tri-Village area booster. Paddock was concerned about the orderly development of town and was instrumental in forming the town's planning board. He served as

The view from Kenwood Avenue toward Paddock Place about 1930. The wooden building in the center is the original Paddock's store. To the left is the brick Paddock business block. To the right is Lang's Department Store. *Courtesy of the Town of Bethlehem.*

This view of the Delmar Four Corners looks from Delaware Avenue toward the Wood commercial block with the Tydol gas station on the corner. Delaware Avenue heads off to the left and Kenwood Avenue to the right. *Courtesy of the Town of Bethlehem.*

its chairman from its inception in 1944 until his death in 1969. Paddock Place, the short road that makes the Delmar Five Corners a more accurate description, is named after the family.

Across Delaware Avenue, where Key Bank is today, another wooden building housed the Delmar Hotel, a hotel, dance hall and saloon operated by Mr. Crum. This structure was removed to make way for the Wood Building, another substantial two-story brick edifice. Bennett Wood had it built with his son Thomas in mind. Shops like Woods 5-10-25 Store, Carroll's Pharmacy and Tad's Men's Shop were on the first floor, with apartments above and a gas station on the corner with Kenwood Avenue. The imposing brick building was removed in 1974 to make way for the bank. Arthur Starman ran Carroll's Pharmacy from the late 1930s until about 1960, when he sold it to Al Warner. Bennett Wood and Damian Schnur founded the nearby Schnur and Wood Feed Store.

Thoughts About the Name Delmar

The name Delmar is something of a mystery that might only be solved in the long-ago files of the Delaware and Hudson Railroad. The hamlet was known as Adamsville when the railroad came through in 1863. The stop here was known as Adams Station for the prominent family. It didn't hurt that J.R. Adams (Nathaniel's son John) contributed half the cost for constructing the station. However, by 1891, the D&H was calling the stop Delmar. One story I have heard is that there was another Adams Station on the D&H and that was causing confusion. What is clear is that by 1900, the name Adamsville had fallen by the wayside, and Delmar had taken over.

So where did Delmar come from? My opinion is that somewhere in the rolls of the D&H is a person with the first or last name of Delmar. Stops on the railroad were often named for the local railroad agent or station master. It seems logical to me that that is what happened in Delmar because we are certainly not near the sea, as the name could imply.

New York's Board of Geographic Names published a report in 1914 that carried this description of the name Adams Station that includes an amusing commentary on the name Delmar: "Adams Station. Hamlet. Named for Nathaniel Adams, early settler. Also known as Adamsville. (Now Delmar, absurd misappropriation of well-known town name on border of Delaware and Maryland.)"

Whether an absurd misappropriation or person's name, Delmar is here to stay.

Part III

TRANSPORTATION

Chapter 15

THE RAIL IN THE TRAIL

BEGINNINGS

Wednesday, September 16, 1863, was a banner day for the Albany and Susquehanna Railroad. That day marked the opening of the first section of rails to be completed, stretching from Albany to Central Bridge, including stops at Adamsville, Slingerlands and New Scotland. One can imagine the excitement in these rural hamlets as the mighty steam engine rolled through. The hamlets haven't been the same since.

Interest in a railroad line connecting Albany and the upper Susquehanna Valley goes back as early as 1844 and took off under the promotion of Albany hotel owner and businessman Edward C. Delevan in 1851. Investors saw the advantage of connecting the valley's fertile farms with the market in Albany and, more importantly, connecting the coal fields of Pennsylvania to Albany and eastern New York. Through the 1850s and '60s, investors, stockholders and the board of directors wrangled over financing, inching the line along as funds were secured.

Finally, on December 31, 1868, the line's 142 miles to Binghamton were completed, and a gala excursion train from Albany was planned for January 12, 1869. The line was built with sixty-pound iron and a six-foot gauge, enabling it to connect freely with the Erie Railroad in Binghamton. Railroad president Joseph Ramsey looked forward to business as usual with the line finally complete. Alas, Wall Street financiers Jay Gould and James Fisk had different ideas.

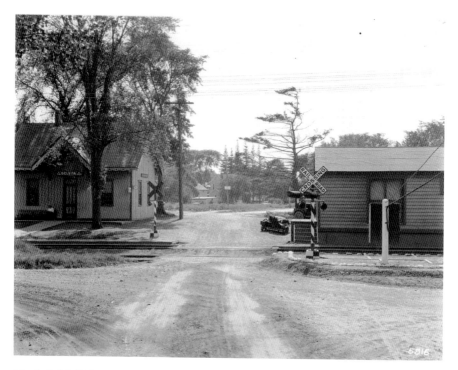

On the left is Delmar passenger station; on the right is the freight house. This photo, taken about 1930, looks down Adams Street toward Kenwood Avenue. The road in the foreground parallel with the tracks is today's Hudson Avenue. *Courtesy of Randy Bushart.*

Gould and Fisk have been described as aggressive capitalists, robber barons and the terrors of Wall Street. The profit to be made from moving coal, the black diamonds of Pennsylvania, to eastern New York was irresistible to these two. They already controlled the Erie Railroad and set their sights on the Albany and Susquehanna. In the spring and summer of 1869, Gould and Fisk began their proxy war, buying up stock and trying to wrest control of the board of directors from Ramsey.

A high point—more actually a low point—happened in August 1869 when each side, having secured judicial orders affirming their control of the railroad, boarded opposing trains and barreled along the tracks toward each other. Fisk grabbed control of A&S trains in Binghamton, loaded them with Erie railroad men and headed east, taking over the stations as he went. Meanwhile, Ramsey's supporters in Albany, including Superintendent J.W. Van Valkenburgh, rounded up men from the Albany shops and headed west. The confrontation happened at the Belden Hill Tunnel. Jim Shaughnessy,

in his book *Delaware & Hudson: The History of an Important Railroad Whose Antecedent Was a Canal Network to Transport Coal*, describes it vividly: "The two locomotives met with a sickening thud on a curve just east of the tunnel and the Donnybrook was on, with hordes of shouting, cursing men spilling off the trains and lunging at each other. Shots were fired in the ensuing melee, clubs were swung, noses bloodied in the general pandemonium."

The Fisk crowd was soon in retreat. Later that evening, another confrontation at the other end of the tunnel began, only to be halted by the arrival of the Forty-fourth Regiment of the state militia, which was called out by Broom County officials to restore law and order. Due to the violence and lawlessness, the governor put the line under military control while the two factions continued to fight it out in the courts. Gould and Fisk's financial buccaneering came to end in January 1870 with Judge E. Darwin Smith's affirmation of Ramsey's control of the Albany and Susquehanna.

On February 24, 1870, the weary board of the A&S leased the line in perpetuity to the Delaware and Hudson. The A&S and the D&H had been working successfully together as early as 1866, with the D&H moving its coal on A&S cars.

TRANSFORMATION

The railroad's arrival in the small towns of Bethlehem and New Scotland led to a transportation transformation in the movement of freight and people.

While there was an established network of roads (including plank roads and turnpikes), the condition of those roads was terrible. Travel by wagon or stagecoach on the rutted dirt roads was a jarring, bumpy and time-consuming ride. Spring rains turned them into mud, and winter snow made them impassable. While Bethlehem farmers continued to take advantage of the Hudson River for transport, the railroad (including the D&H and the West Shore Railroad) increased access to markets for their cash crops and local commodities such as molding sand. Loading up a freight car became an easy option.

People wishing to travel to Albany soon saw the advantage of the railroad's regularly scheduled trips. In 1864, one could purchase a twenty-cent ticket, hop on the train in Adamsville (now Delmar) at 8:45 a.m. and arrive fifteen minutes later in Albany. After business, shopping and maybe lunch, the train left Albany at 2:00 p.m. for the return trip—all without hitching up

Two sides of a 1909 Delaware and Hudson Company timetable of trains. One-way fare from Albany to Delmar is just $0.18. Sixty "trip monthly commutation tickets" are $4.25. *Courtesy of Brian Dootz.*

the horses and braving the roads. Express service for packages and mail soon made its appearance, with one's Sears and Roebuck order arriving for easy pickup at the local station. Western Union's telegraph service made communication even faster.

Commuters began to use the D&H for daily travel between their quiet country homes in Delmar and Slingerlands (and later Elsmere) and their offices in Albany. Suburbanization had begun. Incidentally, the use of the word "commuting" to describe this travel activity sprang from early railroad riders getting their fares "commuted" or reduced because of how often they rode.

STATIONS ALONG THE WAY

In 1863, when the railroad came through, Elsmere was not even on the map. A scattering of farms was located on the Delaware Turnpike with more substantial communities being located at nearby Delmar and Normansville. However, by 1891 passenger service was established here for the growing suburb. According to the D&H, the name Elsmere came from the popular novel *Robert Elsmere*, which was published in 1888.

Delmar got its start as the hamlet of Adamsville, named after Nathaniel Adams, who opened his hotel here in 1838. D&H records indicate that Adams Station was built in 1866, with half the cost being contributed by J.R. Adams (John R. Adams, Nathaniel's son). The Adams Hotel is just two blocks away from the station. By 1891, the D&H was calling the station Delmar, and by 1900, the name Adamsville had dropped out of use.

Formerly known as Normanskill, Slingerlands is named after the prominent Slingerland family who settled here in the 1790s. When the railroad came through in 1863, Slingerlands was an established hamlet with a post office, stores and a school. The community soon capitalized on the station, with many railroad executives building their homes here. One was Charles Hammond, who was the director of the Northern Division of the Delaware and Hudson. He built his Victorian-style home in 1876 within view of the Slingerlands station.

In the 1860s, the West Shore Railroad and the Albany and Susquehanna Railroad crossed in a farmer's field in northern New Scotland. Early A&S Railroad schedules refer to the hamlet that grew up around the junction as New Scotland (not to be confused with the station on the West Shore Railroad also known as New Scotland). By 1870, the hamlet was known as Voorheesville, and it was formally incorporated in 1899. It was named after Alonzo B. Voorhees, an Albany attorney who also established the post office there. The village spent a brief time (August 1890–92) known as Farlin after railroad agent Dudley Farlin.

TODAY

Passenger service on this section of the D&H line ended in the 1930s. Freight service continued through the 1990s, with the actual rails being removed in 2004. In 2010, Albany County completed the purchase of

9.1 miles of rail bed from the Canadian Pacific Railway to create the Helderberg Hudson Rail Trail. In June 2011, Albany County, the Town of Bethlehem and the Mohawk Hudson Land Conservancy partnered to open a 1.9-mile section of the trail to the public. The ultimate goal is to open the entire trail from Albany to Voorheesville for recreation and as an alternative transportation route between Albany and the suburbs along the former railroad line.

Chapter 16

ELSMERE STATION

A version of this article was first published in the December 2013 issue of
Our Towne Bethlehem.

In 1863, when the Albany and Susquehanna Railroad came through town, Elsmere was not even on the map. The section of the Delaware Turnpike between the Normanskill (and the hamlet of Upper Hollow) and Adamsville (now Delmar) was sparsely populated. The 1866 Beers map has nine houses and one hotel in the mile-and-a-quarter stretch along the turnpike. Groesbeck, Clark, Salisbury and Scrafford were families along the route.

Seven years later, when the Delaware and Hudson Railway took over the line, Elsmere did not have a station. It isn't until 1891 that Beers's atlas listed an East Delmar Station here. The D&H wrote in *Passenger and Freight Stations on the Delaware and Hudson*, published in 1928, that Elsmere station was built in 1899 "upon petition of the residents of that rapidly growing suburban village…the name was suggested by Mr. J. White Sprong. At that time the novel *Robert Elsmere* was very popular. Population 600."

As the D&H article indicates, Elsmere began growing around the turn of the twentieth century. Farms were subdivided and houses built, and families were moving in. A notice in the March 20, 1896 issue of the *Altamont Enterprise* reads, "There is yet one more house to rent, on Delaware Ave near Elsmere Ave. A very spacious, desirable, two-story house, attic, cellar, good barn, near Elsmere station. We hope it will rent soon to some one who will help to boom Elsmere."

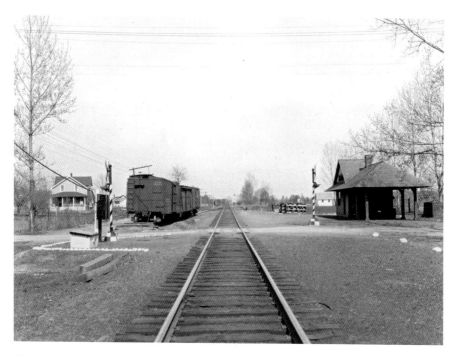

Elsmere station is on the right and a siding with freight cars is on the left of this circa 1930 photo that looks east along the D&H tracks. The light smudge that crosses the tracks is Elsmere Avenue, at the time a level grade crossing. *Courtesy of Randy Bushart.*

As the area began to "boom," the one-room school at Normansville was soon overcrowded, and School District No. 15 at Elsmere was established. Elsmere's one-room school was built near the railroad station in 1911, expanded in 1915 and totally replaced in 1928 by the Elsmere School on Delaware Avenue.

An indication of Elsmere's growth and residential character is found when, in 1912, residents petitioned to the Public Service Commission for freight and baggage service at the railroad. Unfortunately, the commission found Elsmere to be a collection of residences without business of any kind, and the petition was denied. The increasing popularity of personal automobiles combined with frequent bus service between Elsmere and Albany led the D&H to discontinue passenger service in 1933. Freight trains were still traveling the tracks into the 1990s.

Today, when one turns from Delaware Avenue onto Elsmere Avenue, heading down under the railroad bridge, it is hard to believe this road was once level. In the early 1930s, three of the D&H's level grade crossings proved

to be dangerous to automobile drivers. Here on Elsmere Avenue, as well as on Delaware Avenue in Delmar and New Scotland Road in Slingerlands, the area was excavated and infrastructure installed so that the roads went under the tracks.

Heading south, as you come up from under the tracks, stairs reach up from the sidewalk on both sides of the street. Those on the left reach to the location where the Elsmere Station and the one-room Elsmere School used to stand. Today's Nathaniel Adams Blanchard Post of the American Legion occupies the property. On the other side, stairs reach toward a private residence that used to be a grocery store and the Elsmere post office.

GROESBECK'S CORNERS

The land where Elsmere Station was located was once owned by John I. Groesbeck, and for a time the area was known as Groesbeck's Corners. Groesbeck purchased 130 acres here in November 1831 from Timothy

A map of part of the Groesbeck farm at Elsmere shows the railroad station with the tracks labeled "A&S R.R." for Albany and Susquehanna Railroad. *Courtesy of the Town of Bethlehem.*

Bussing Jr. and his wife, Angelina. The land was described in lengths of chain beginning at a sassafras tree. The purchase was subject to rents due to Stephen Van Rensselaer from Bussing's purchase/rental of the property in 1799.

In the 1700s and earlier, the land hereabouts was owned by the Van Rensselaer family and was part of Van Rensselaer Manor. The manor was a fiefdom where the patroon collected annual rents from his tenants. A common early rent was sixteen bushels of wheat, one day's service with a team and four fat fowl. This system fell apart with the death of Stephen Van Rensselaer, the last patroon, in 1839, and the subsequent Anti-Rent War. Groesbeck negotiated the release of the rent from Stephen Van Rensselaer and his wife, Harriet, in 1855 for consideration of $333.33.

John I. Groesbeck is a descendant of Claes Jacobse Groesbeck and Elizabeth Stevens. By 1660, Claes and Elizabeth had emigrated from Holland to New Netherland and were residing in Beverwyck (today's Albany). John was born in 1795 and died in 1880. He was a veteran of the War of 1812, having served as a private with Captain Van Benthhuyser's Company of the New York Militia from September to December 1814. His first wife was Maria Radliff, with whom he had nine children. His second wife was Jane Ann Vander Hayden Hallenbeck, with whom he had three children. Today in Elsmere, the family name is remembered in Groesbeck Place.

Chapter 17

NORMANSKILL BRIDGES AT NORMANSVILLE

A version of this article was first published in April 2014 in
Our Towne Bethlehem.

As you travel along Delaware Avenue over into Albany, do you notice the waters of the Normanskill flowing many feet below you? You are passing over a vital part of Bethlehem's history.

Petanock, Secktanock and Tawasentha are early Indian names of the creek we know today as the Normanskill. The vale of Tawasentha was immortalized in the introduction to Longfellow's *Song of Hiawatha*. In early Dutch, *Normans Kill* means "Norwegian's Creek." Albert Andriessen Bradt is that Norwegian.

Bradt; his wife, Annetie; and their three children arrived at Fort Orange on April 7, 1637. One of those children was born aboard ship during the Atlantic crossing. Albert and Annetie named him Storm. They would eventually have five more children. Bradt made his living through a variety of endeavors, including sawmilling (at one time his mills were producing six thousand board feet a day), farming, fishing, raising cattle and dabbling in the fur trade. Much of this activity happened in the environs of the creek that would bear his name.

The precursor to Delaware Avenue, the Albany and Delaware Turnpike Company, was chartered in 1805. The company's road-building efforts included a one-hundred-foot-long wooden bridge over the Normanskill. A tollgate was located just over the river on the west shore, and Peter

A modern view of the Normansville bridges. The upper bridge carries Delaware Avenue over the Normanskill. *Courtesy of the author.*

Esmay was the toll collector for many years. The hamlet, then known as the Upper Hollow, began forming on both sides of the creek near the bridge, with various mills making use of the water power. A hotel, church and school were established. By the time Howell and Tenney published their *Bi-Centennial History of Albany County* in 1886, the hamlet was known as Normansville and there were seventeen dwellings, twenty-two families and one hundred inhabitants.

The low, wooden bridge was carried away by a freshet in 1868. By this time, the turnpike company had abandoned the road. It fell to the Town of Bethlehem to build a new two-truss iron bridge in 1869. The concrete bridge that is in place today was built in 1913. In those early days, Delaware Avenue traveled a different path, starting at the high ground near Graceland Cemetery and winding down into the ravine, through the hamlet and over the bridge and up the hill on the other side. This Yellow Brick Road, so named for its distinctive paving, was a main thoroughfare.

In December 1928, the Normanskill Viaduct was completed. The new bridge carried traffic on Delaware Avenue on a more level path high over the

The Normansville Free Chapel, established in 1889, is a landmark in the hamlet of Normansville. *Courtesy of the author.*

creek, easing the journey between Albany and Bethlehem. The hamlet under the bridge, now bypassed by travelers on Delaware Avenue, transitioned to a residential community. This high bridge, in turn, was replaced in 1994. The lower concrete bridge was closed to vehicles in the early 1990s. Emerging out from the asphalt and weeds, one can still find those iconic yellow bricks along Albany's Normanskill Drive and Mill Road.

Interestingly, the river did not become the dividing line between Albany and Bethlehem in this area until 1910. Before that, Bethlehem included much of the Whitehall Road area. Graceland Cemetery did not get annexed to Albany until 1976.

THE SONG OF HIAWATHA

Whenever I give a history hike through the village of Normansville, along the tumbling creek once known as Tawasentha, I always start with the

Native Americans who were present here long before Europeans came upon the scene. Mohawks and Mohicans called this place home. I recall the Two Rows Wampum and the very early—some say the very first—covenant between native people and Europeans that took place here in 1613. And I read this excerpt from the introduction of Henry Wadsworth Longfellow's *Song of Hiawatha*. While the valley is not so silent anymore, what with the rumble of Delaware Avenue emanating from overhead, if one pauses to listen, the waters of the Normanskill are still sighing and singing.

> *In the vale of Tawasentha,*
> *In the green and silent valley,*
> *By the pleasant water-courses,*
> *Dwelt the singer Nawadaha.*
> *Round about the Indian village*
> *Spread the meadows and the corn-fields,*
> *And beyond them stood the forest,*
> *Stood the groves of singing pine-trees,*
> *Green in Summer, white in Winter,*
> *Ever sighing, ever singing.*
> *And the pleasant water-courses,*
> *You could trace them through the valley,*
> *By the rushing in the Spring-time,*
> *By the alders in the Summer,*
> *By the white fog in the Autumn,*
> *By the black line in the Winter;*
> *And beside them dwelt the singer,*
> *In the vale of Tawasentha,*
> *In the green and silent valley.*

A Visit to the Norman's Kill

I wrote this blog post after kayaking along the Normanskill on Labor Day, September 1, 2014. It begins with two questions: who is Norman, and who did he kill?

No one, as it turns out. Living in the Hudson River Valley, one must have a smattering of Dutch. *Norman*, or *Noorman*, is Dutch for Northman, Norseman or Norwegian. *Kill*, or *kil*, is creek. Therefore, we have Norwegian's Creek. So who is this Norwegian, and why did the creek get named after him?

The Norman in question is Albert Andriessen Bradt, often known simply as the Noorman. Albert was born about 1607 in Fredrikstad, Norway. At some point, his family moved to Amsterdam, where there was a sizable Norwegian community. On August 26, 1636, Albert and two others signed a contract with the patroon Killaen van Rensselaer to establish a new sawmill venture in Van Rensselaer's colony Rensselaerswyck. In October, Albert; his wife, Annatie Barents; their two young daughters; and about thirty-five other passengers set sail. "Most of the men were farmers or farm laborers, but there were also smiths, shoemakers, carpenters, a millwright and a mason, all trades of necessity to the frontier community." After an eventful crossing, the ship finally arrived at Fort Orange on April 7, 1637. (Albert and Annatie would eventually have eight children in total, one of whom, named Storm, was born during this crossing.)

Albert set about creating a life for himself and his family in the frontier community that would later become Albany and Bethlehem. He was a woodcutter, sawmiller, tobacco planter, orchardman and trader. He accumulated wealth and acreage (including some in New Amsterdam, today's Manhattan). While a respected businessman and an elder in the Lutheran Church (a somewhat dangerous prospect given the dominance of the Reformed Church at that time), he was also known to be "irascible," a difficult neighbor and a thorn in the side of the patroon.

Albert, who died on June 7, 1686, was "a man of vision in a new world, a settler in a strange land, one of the founders of a colony. He…reached a position of respect, then watched his sons surpass him…in his later years he was separated from his wife [wife #3, not Annatie], alone and bitter, watching his children pursue a strange religion."

All of the above quotes are from Peter R. Christoph's publication *A Norwegian Pioneer in a Dutch Colony: The Life and Times of Albert Andriessen Bradt: Miller, Merchant, and a Founder of the Lutheran Church in America.* Christoph does a marvelous job of presenting the complicated man who was Albert Bradt in the context of his times using primary sources. You can find it at the Bethlehem Public Library under the title *A Norwegian Family in Colonial America.*

Given Bradt's prosperity, cantankerous nature and notoriety, it is no wonder the creek became known as the Norman's Kill.

Finally, another small note on the river's name. Is it Normanskill, Norman's Kill or Normans Kill? I've read all of those on maps and reference books both old and new. My personal preference is the one word "Normanskill" because that's how it flows when I speak. But never say the Normanskill Creek because then you really have Norman's Creek Creek. To be grammatically correct, it should be Norman's Kill.

Chapter 18

TURNPIKES AND PLANK ROADS

Originally published in the February 2015 Our Towne Bethlehem.

It is safe to say that the state of the roads has always been of concern to Bethlehem's residents. At Bethlehem's first town meeting on April 10, 1794, 220 years ago, three commissioners of the highways were chosen—George Hogan, John Burnside and Teunis Houghtelin—along with twenty overseers of the highways. Indeed, at that first town meeting, only three resolutions are recorded. One set the next town meeting for the following year. The other two reflect the rural nature of the town and residents' concern for safe travel on the roads. "The following resolutions was likewise voted at the same time for the more orderly keeping of cattle. 1st That no stallion or stallions or unruly cattle shall be allowed to run at large in the public highways. 2nd That no swine shall be allowed to run at large in the public highways."

Strict records were kept about the "doings" of the commissioners of the highways. They certified that proposed roads were "necessary and proper" or, less often, "denied and refused" a proposed highway. Surveys in links and chains that reference property owners, fences and trees were recorded. Here's one from May 17, 1795: "Laying out a road beginning at the Omsgriethan road at old John Haswells when the road turns to John Leonards to and along a northwesterly course to Timothy Bussing, Jr. crossing the school road and saw mill road below the saw mill of Gansevoort."

In those days, it was expected that roads would be maintained by the owners of the property that the road passed through. The overseers of the highway had specific roads they had charge of. For example, in 1775, Amos Jones was the overseer of the road from "Nicolas Hallenback until Renselars Mill Road." Figuring out exactly where these roads were is a huge challenge.

More easily mapped are the toll and plank roads that were laid out in Bethlehem. The Delaware Turnpike, today's Delaware Avenue, chartered in 1805, is the easiest as the course of the road has not changed. The Albany and Bethlehem Turnpike Road was chartered in 1804 and followed a path from today's South Pearl Street (then the Bethlehem Road) swinging up Corning Hill and then heading south to Bethlehem Center (parts of modern-day Route 9W). In exchange for building and maintaining the roads, these private turnpike corporations were allowed to collect tolls.

This tollgate for the Albany and Bethlehem Turnpike was located on what is now South Pearl Street in Albany near Kenwood Road. When the turnpike was incorporated in 1804, this section was part of the town of Bethlehem. Tracing South Pearl Street, Old South Pearl Street and Old Route 9W on modern maps gives a feel for the course of the turnpike. *Courtesy of the Town of Bethlehem.*

In 1847, the New York State Plank Road Act was passed. Plank roads were literally "paved" in planks of wood laid crosswise. *The Plank Road* manual published in 1848 recommends hemlock as the "best and cheapest for the track, cheaper than oak by half and wearing better than pine." Another writer in 1849, civil engineer George Geddes, points out that if the road companies had "lumber at low prices and great amounts of travel," they could realize "handsome dividends." However, plank roads soon fell out of favor. The wood would only last about seven years, at best, often not enough time to make a good profit.

The South Bethlehem Plank Road was organized in 1851 to connect Babcocks Corners (Bethlehem Center/Glenmont today) to Janes Corners (South Bethlehem today). It commenced where Feura Bush Road intersects 9W and carried on southward along parts of 9W and Lasher Road. Feura Bush Road was the Albany and Clarksville Plank Road, and the southern part of River Road was the Albany–Green County Turnpike. New Scotland Road was once the Albany, Rensselaerville and Schoharie Plank Road.

Over the years, all the roads maintained by these private companies were taken over by the state, county or local highway departments. That is why today, many of the main roads in town, like Delaware Avenue and Feura Bush Road, are New York State roads and not Bethlehem town roads.

COLLECTING TOLLS

All of the toll roads mentioned above had a series of tollgates with rates of toll clearly delineated. For example, a sign for the Albany and Bethlehem Turnpike lists six cents for every score of sheep or hogs, six cents for every covered stage wagon drawn by two horses, four cents for every one-horse sleigh and four cents for every horse and rider.

The tollgate for the South Bethlehem Plank Road was part of a complex of buildings located on the southwest corner of the intersection of today's Feura Bush Road and Route 9W. Mrs. A.M. Babcock was the first gatekeeper. Fittingly, this hamlet was then known as Babcock Corners. Mrs. Babcock kept a sharp eye out for those who tried to avoid paying the toll by dashing their horses around the gate. She also ran the post office here and made sales at her candy counter. In order to preserve the tollgate building, it was moved by the Bethlehem Historical Association to the grounds of the Cedar Hill Schoolhouse Museum.

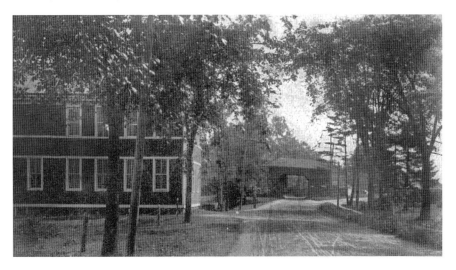

Rates of toll for the Albany and Bethlehem Turnpike ranged from two cents for a led horse to fifteen cents for a score of cattle and included rates for many types of vehicles like the sulky, chaise, cart, chariot and coach. *Courtesy of the Albany Institute of Art and History.*

This postcard looks east along what is now known as New Scotland Road toward the tollgate on the Albany Rensselaerville and Schoharie Plank Road. On the left is the Slingerland Printing Company. Branching off to the right is today's Kenwood Avenue. *Courtesy of the Town of Bethlehem.*

One tollgate for the Albany, Rensselaerville and Schoharie Plank Road, now New Scotland Road in Slingerlands, is memorialized with the nearby Tollgate Restaurant. The gate was located where the road slopes down to the railroad underpass near the former Slingerland Printing Company. It was not removed until 1908.

Travelers back in the day, like travelers today, did not always appreciate having to pay the toll. Besides simply running through the gate without paying, travelers sometimes formed shunpikes. These informal roads went around the toll gate. They literally shunned (avoided) the pike (the road); hence the word shunpike. Today, we find evidence of shunpikes and plank roads mostly in the evidence of street names like Plank Road in Glenmont.

Part IV

FARMING

Chapter 19

DAIRY FARMING IN BETHLEHEM

A version of this article originally appeared in the January 2015 issue of
Our Towne Bethlehem.

Bethlehem's roots as a dairy farming community run deep. Over two hundred years ago, our town was described as being "very fruitful in pastures, and has large quantities of excellent butter." Butter, of course, is made by churning milk to separate the butter fat from the buttermilk. The USDA Census of Agriculture reports that in 2012 there were 1,431 milk cows in Albany County providing this vital fluid.

Longtime residents remember the days when Bethlehem had many working dairy farms. These included Heath's Shady Lawn Dairy, Norman's Kill Farm Dairy and 3 Farms Dairy. Today, only Meadowbrook Farms Dairy just over the New Scotland town line in Clarksville still delivers milk door to door.

While the farm's roots go back to Kelderhouse family who lived and farmed here as early as 1810, Shady Lawn Dairy was established at the corner of today's Wemple Road and Route 9W by William and Elvira Heath in 1920. They started with 67 acres and 19 cows and grew their operation to 450 acres and 225 Holsteins. New York census records from 1925 indicate that William Heath, age thirty-three, lived on Bethlehem Road. His occupation is listed as dairyman. Elvira, also age thirteen, and their four children (Aileen, Jerald, Margaret and William) are also listed, as is Heath's mother, Elizabeth (age seventy-two). Heath's Dairy included

Today, the former Shady Lawn Dairy stands forlorn at the corner of Route 9W and Wemple Road. *Courtesy of the author.*

a home delivery service and a store located on the premises. In the 1950s, store customers could enjoy a glimpse of the milking parlor located next door. William H. Heath died in 1987 at age ninety-six. By the time the dairy closed operations in the late 1980s, it was owned by Barry Dance.

The Norman's Kill Farm Dairy was a large operation ranging from the cows on the farm to the delivery of milk products door to door. The dairy was established in 1900 by Mark Stevens and had its peak years from about 1920 to 1960. The original Stevens farm where cows were pastured and milked was located in Normansville. A second farm, known as Norman's Kill Dairy Farm #2, was located on today's Route 9W, a site now occupied by big box stores. Here you could look through the large windows in the barn and see brown and white Guernsey cows being milked.

These two Norman's Kill farms and others in Albany County sent their milk to be processed and bottled at the company plant in downtown Albany at 120 South Swan Street. (This location got in the way of Governor Rockefeller's remodeling project that came to be known as the Empire State Plaza.) According to a 1919 report, Albany County had twelve such plants producing milk, butter, cream and ice cream, plus one that produced Italian and Greek cheeses. Norman's Kill Farm Dairy delivered door to door in horse-drawn wagons and later trucks. Advertising in the 1930s featured the charming "Normie" urging folks to buy Velvet Ice Cream.

A 1954 partnership resulted in the formation of the 3 Farms Dairy. The three farms were those of Ernest Newell on Wemple Road, brothers

In this circa 1960 postcard, blue and white trucks stand ready to make deliveries for the 3 Farms Dairy. *Courtesy of the author.*

Bernard and Edward Mocker on River Road and Neil Goes at Cedar Hill near the Hudson River. They began with more than two hundred head of dairy cattle. The milk was processed and dairy products sold at the farm store at the Mockers' property. Until 1975, home delivery was also an option. Customers could choose from ice cream, cottage cheese, sour cream, milk, butter and other products all made at the River Road store. In the early 1980s, they stopped processing locally but continued to sell their milk wholesale. Tom Newell, son of Ernest Newell, reports that the last cows of 3 Farms Dairy were sold off in 1995.

Meadowbrook Farms Dairy in Clarksville has kept up home delivery of milk for almost ninety years. The farm has been in the Van Wie family since 1850, and the dairy was started in 1926 by Charles Van Wie. Today, it is known for its responsibly raised cows that eat grass, hay, alfalfa and corn grown on the property and produce fresh, creamy and tasty milk. Meadowbrook Farms still makes home deliveries as well as selling its milk at local stores and farmers' markets.

DUTCH BARNS AND ENGLISH BARNS

This article appeared in the May 2015 edition of Our Towne Bethlehem.

Utilitarian, rustic, commonplace. Bethlehem barns are all those, as well as functional, useful, spacious, soaring and sheltering. Reflecting the heritage of those who constructed them, early barns here fall into two general categories: Dutch barns and English barns. While only a few Dutch barns are left in town, there are many examples of English barns.

The New World Dutch barn echoes the early Dutch settlement in our area. Built between 1630 and 1825, these barns are the all-purpose building on the farm, housing animals, storing hay and providing a threshing floor for grain. They are typically square shaped. Doors are located on the gable end and are sometimes split like a typical Dutch door. The lower half could be closed to keep animals in while the upper portion is open for light and ventilation. Inside, H-bent construction is evident in the vertical posts and horizontal anchor beams joined with mortise and tenon joints. The H-bents, huge and solid marching down the center of the barn, create a central aisle that is surprisingly airy and lofty.

The Zdgiebloski barn on Elm Avenue is one extant example of Dutch barns in Bethlehem. Henry and Helen Zdgiebloski, both born in Poland, were doing general farming here by the 1930 U.S. census. The census indicates they lived on Houck's Corners Cross Road with their five sons: Stanley, Henry, Peter, Joseph and John. Their children attended the one-room school at Houck's Corners. Houck's Corners is the intersection of

today's Feura Bush Road and Elm Avenue. The *Altamont Enterprise* provides us with a glimpse of the children's activities in the 1930s. Both Joseph and John participated in a district-wide School Garden Exhibit in September 1935. Stanley must have raised his own cattle; he advertised often in the 1930s selling Guernsey cows. The barn and farmhouse continue in the Zdgiebloski family today. The barn was likely built much earlier than the Zdgiebloskis' ownership, possibly around the time that Jacob Kimmey signed a lease with the patroon in 1792.

Settlers with roots in New England tended to construct English-style barns. Many of these folks arrived in Bethlehem, Albany County and points west after the American Revolution. English barns contrast to Dutch barns by being generally rectangular in shape with large doors in the middle of the long side. By the mid-1800s, farmers were adapting their barns to the growing dairy industry by raising the barns onto taller foundations, creating a basement level.

Such basement barns became typical and widespread. The lower level was created with a foundation of stone or concrete, and this is where the animals were housed. The main level was a threshing floor and storage for grain and equipment. Lofts filled the heights for hay storage. The main level was sometimes reached by a dirt ramp and wooden bridge.

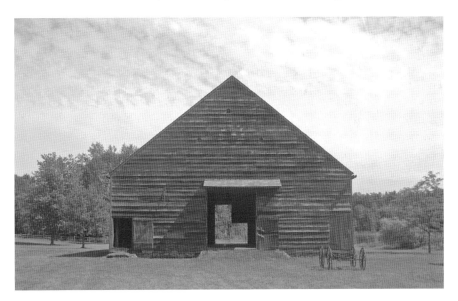

The Wemp barn on Onesquethaw Creek Road in Feura Bush is a New World Dutch barn. It is owned by the Dutch Barn Preservation Society and is open to the public. *Courtesy of the author.*

A variety of farm structures are visible behind the horse, including an English-style barn on the left. From left to right are unknown, Dorothy Wright, Elizabeth Wright, Esther Wright and Walter Wright. *Courtesy of the Town of Bethlehem.*

The yellow barns on Clapper Road are part of the 205 acres that Abraham and Wilhelmus Westervelt obtained from the patroon in 1808. By the 1840s, they were successful enough for each to build elegant homes with Greek Revival styling for themselves and their families. When built, the homes were close neighbors; today, they are separated by the New York State Thruway.

Abraham's home came down through the Clapper family and stands near the yellow farm buildings. Although they grew garden produce like cantaloupes and potatoes, the Clappers' principal crop was hay. In the days before automobiles, hay was an important commodity. The largest yellow barn on the property, constructed in 1882, features a built-in press powered by horses that compressed hay into bales. The bales were then carted to the dock for shipment on the Hudson River to market in New York City. The hay barn has elements of a basement barn, with earthen banks leading to the large doors on the long side; however, it was always intended for hay storage and processing. Animals were not kept on the lower level.

With all this discussion of types of barns, it is important to keep in mind that these are truly functional buildings that are often adapted as needed by their owners creating additions and alterations, making for unique buildings.

Chapter 21

GRANDFATHER WINNE'S HOUSE DOWN ON WINNE ROAD

This is the very first "Then & Now" article I wrote for Our Towne Bethlehem, *published in February 2013. The title comes from the note handwritten on the back of the photo by Nancy Winne, granddaughter of John L. Winne.*

Do you recognize this Bethlehem farmhouse? It is hiding in plain sight on Roweland Avenue in Delmar. Today, it sits a bit awkwardly on a tidy suburban lot. The driveway from Roweland leads to a welcoming front door that is actually the rear of the house. The elegant, recessed front door with its Greek Revival details faces the back of the lot and looks out onto Louise Street. John L. Winne began farming here in 1861 and probably built the house around 1870 when it was part of his one-hundred-plus-acre farm at Adams Station (now Delmar). The farm was described as "one of the neatest and most productive in the town, presenting evidences of care and industrious cultivation."

The photo shows Winne proudly standing by his white picket fence. Nearby is a set of steps used to climb into a carriage or wagon. Notice the architectural details around the front door and the eyebrow windows in the gable. Chairs on the porch invite one to sit a spell—a perfect picture of rural comfort. Beyond the home are the open spaces of field and meadow. At its largest, 167 acres, Winne farmed rye, corn, oats and buckwheat and had an orchard of one hundred apple trees.

Howell and Tinney's *Bi-Centennial History of the County of Albany* describes Winne as "one of the best known and most popular citizens of the town

John I. Winne stands at the front of his farmhouse about 1900. *Courtesy of Shirley Winne.*

of Bethlehem. He ranks as a leading farmer and is recognized as one of the progressive, self-made men of the town." Described as a "staunch Republican," Winne served as Bethlehem's town supervisor from 1883 to 1885. His first wife, whom he married in 1846, was Margaret Clickman; his second was Rebecca Flansberg, whom he married in 1865.

November 4, 1903, was a fateful day for Winne. At age eighty-two, he was working in the barn and fell from a set of stairs, striking his head and dying shortly thereafter. His heirs—three sons and four daughters—could not agree on the settlement of the farm and ended up breaking it up and selling it off. As happened all over Delmar, the large farm gave way to the suburban homes of today. Gradually, new roads filled in, the land was subdivided and Grandfather Winne's home was no longer on Winne Road.

Chapter 22

THE LAGRANGE FARM

Published in the June 2013 issue of Our Towne Bethlehem.

One hundred beaver skins and 250 pounds sterling were what it took to buy large tracts of land at the turn of the seventeenth century in what was to become the towns of Bethlehem and New Scotland. In 1686, Omie de LaGrange purchased half of the Van Baal patent from Jan Hendrickse Vroman and, in 1716, with partner Simones Vedder, purchased the remaining half—a total of sixty-nine thousand acres. LaGrange and his brother Isaac soon settled on a large piece near the Normanskill and began to make a living. LaGrange married Annatie DeVries and raised a family. He was described as "a true pioneer, a man of strength and courage, farmer, hunter, trapper; he founded a family which holds prominent place in the county as men of affairs and large land owners."

Other settlers soon followed, leasing their farms from LaGrange. This did not sit well with the patroon of Rensselaerswyck Manor, who also laid claim to the property. The Van Rensselaers filed suit. The case took years to resolve, with the court finally ruling in favor of the Van Rensselaers in 1776. The LaGranges, Vedders and sixty-three settlers were now without "estate or home." The LaGranges especially found themselves tenants on property they had owned for over seventy-five years. Time, of course, marches on, and the results of the Anti-Rent War of the 1840s made them owners again. LaGrange's descendants farmed this land until 1954, when it was sold out of the family.

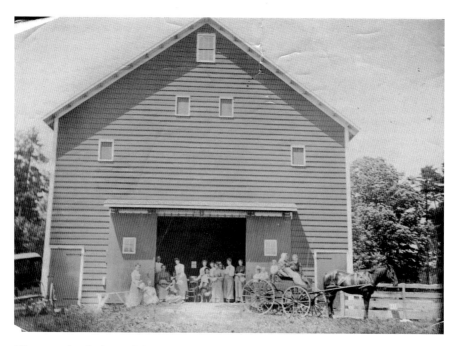

Women gather in front of the cow barn at the LaGrange farm about 1900. *Courtesy of Garry McBride.*

Some of those descendants include Christian I. LaGrange (1779–1848) and his wife, Jamima LaGrange (1796–1828), who are buried in the family cemetery. That cemetery now finds itself in the center of a soon-to-be busy roundabout in the Vista Technology Park in Slingerlands. Also buried here are two of their sons, Abram and Christian. Abram C. LaGrange (1822–1859) is described as "unmarried; a man well known, an extensive cattle and sheep grower and dealer, who amassed a fortune." Christian C. LaGrange (1826–1851) is described only as "unmarried; a deaf mute." There is also a small stone simply marked "G. Mason."

Culver Reynolds, whose descriptions of the LaGrange family in *Hudson-Mohawk Genealogical and Family Memoirs* are quoted here, describes the farm during Christopher C. LaGrange's tenancy as follows. (This Christopher is a grandson of Christian and Jamima.)

> He [Christopher] *inherited a fine estate of two hundred and sixty-eight acres, the finest and most fertile land in the town, all under cultivation except forty acres of valuable timber…The buildings are modern filled with all the aids to successful farming…The large orchards are in full*

104

*bearing and a source of profit...He has given special attention to fine stock
breeding, Percheron horses of pure breed being his specialty.*

Christopher LaGrange and wife Mary C. Vosberg's daughter Ella
LaGrange McBride (1875–1955) also farmed this land. Ella married Garry
McBride, a Delmar mechanic who was not interested in farming. She
received recognition in 1939 as a Double Century Farmer. Century Farms
is a program of the New York State Agricultural Society that began in 1937
and continues today. It honors New York farms that have been in continuous
operation on the same land by the same family for one hundred or more
years. A Double Century recognizes over two hundred years.

In 1947, Ralph Mosher leased some of the farmland from Dr. Garry
McBride (son of Ella LaGrange McBride). Many remember the buzz of
planes taking off from the turf landing strip of Mosher's Tri-Village Airport.
The airport, located in the vicinity of today's Shop Rite, closed in 1984.
Amazingly, at that time (the late 1940s and '50s), Bethlehem boasted three
other airfields. The Normanside Airport, established by Dominic Chiore
and Santo Italiano, was just a few miles north of Tri-Village off Blessing
Road. It opened in 1947 and closed in 1954. In the southern part of town,

The LaGrange cemetery is seen here in 1993 with the cow barn in the background. *Courtesy
of Garry McBride.*

the South Albany Airport, established in 1942 by William VanValkenburg, is still a thriving operation. In the 1940s, Shelly Edmundson ran an airstrip near a home he owned on Route 9W near Bethlehem's southern boundary.

As Bethlehem looks forward to the future and the benefits of the Vista Technology Campus, it is fitting to remember the past, the farmers and forward thinkers who have contributed to our town's heritage. Sometimes this history is hiding in plain sight: a family cemetery in a roundabout, a farmhouse among the suburban homes or a barn among commercial buildings.

Chapter 23

THE STOFFELS FRUEH FARMHOUSE

Published in the August 2013 edition of Our Towne Bethlehem.

On a recent summer Sunday afternoon, I had the pleasure of chatting with Michael and Sheri Frueh about their historic farmhouse. Situated just north of the intersection of 9W and Wemple Road, at the end of the private Stoffels Lane, the house and nearby property have been in the Stoffels/Frueh family for six generations—seven if you include their two-year-old son, Cameron.

Family patriarch Peter Stoffels came to New York State from Germany as early as 1840. While the current owners have copies of deeds where Peter purchased land in 1876 from the Warren and Milbanks families, an 1870 Albany County business directory lists Peter Stuffle [*sic*] as a Bethlehem farmer with 140 acres. The Stoffels are also listed on the 1866 Beers map. Clearly, the Stoffels were here to stay.

Peter's son William established a dairy operation here that included raising dairy cows and making milk deliveries along a route in Albany. The 1900 U.S. census provides a glimpse into the Stoffels household. William Stoffels was born in New York in October 1840. He was sixty years old at the time of the census, and his father and mother were born in Germany. William owned a 210-acre farm, and his occupation was listed as dairyman. Elizabeth, his wife, was born in New York in May 1842, and her parents were born in Germany. The census notes she had nine children, eight of whom were living. Included in the household were three grown children:

Stoffels family members pose in front of the farmhouse probably in the late 1890s. *Courtesy of Michael and Sheri Frueh.*

The Stoffels milk business making deliveries in Albany. Note the milk cans in the wagon. *Courtesy of Michael and Sheri Frueh.*

Mary, age thirty-one; Peter J., age twenty-nine; and George, age twenty-one. Peter and George were listed as farm laborers.

Peter is the son we are interested in. By the 1910 census, Peter was married to Anna Aussem and living at the family homestead along with their two young daughters, Elizabeth and Adeline. Family lore tells us that Adeline met George Frueh because his family farmed land across the road. Indeed, an item in the July 8, 1932 issue of the *Altamont Enterprise* reports on Elizabeth's surprise twenty-sixth birthday party. Among the guests listed were Adeline Stoffels and George Frueh. The article notes that after bridge and other games were enjoyed, a "dainty repast" was served.

Adeline and George married, and in turn, their son David Frueh Sr. married Gail Curtis. Current owner Michael Frueh is their son. Michael and Sherri Frueh have owned the property for two years now and are taking care to restore it.

Part V

CONFLICT

Chapter 24

BETHLEHEM AND THE AMERICAN REVOLUTION

The first thing one should recognize when considering what Bethlehem was like during the American Revolution is that there was no town of Bethlehem. It was part of the West District of Rensselaerswyck, which was part of Albany County. Albany County was much larger than it is today. Settlement was scattered along the Hudson River, Normanskill and Vlomankill with such familiar family names as Becker, Slingerland, Van Allen, Van Wie and Winne. Dutch was probably still spoken in homes and churches, although the area had been under English rule since 1664. Settlers made their living farming and raising livestock for both subsistence and as cash crops, paying their annual rent to the patroon. Sawmills, gristmills, coopers and blacksmiths were also found.

Bethlehem's residents surely heard the rumblings of discontent with the British government. When news of the Battles of Lexington and Concord arrived in May 1775, Albany's Committee of Correspondence came out into the open and began to organize the resistance to British rule. Residents of the manor would soon be asked to sign a document called "The Association," a pledge of loyalty to the Patriot cause.

Choosing sides would be difficult. Upstate New York demonstrated a strong resistance to anything English, clinging to its Dutch ways. While opposition to English trade laws was found, some upstate New Yorkers resented the influx of settlers from New England and often had an anti-Boston sentiment. There was also tension between the patroon and the tenants on the manor. Some people became Loyalists, some Patriots and

some tried to remain neutral. While many of Bethlehem's farmers joined the Patriot cause, there was also a purported Tory camp near Mead's Lane.

During the years of 1776–77, Albany, and hence Bethlehem, was in the middle of British war efforts, with General Burgoyne maneuvering in the north and General Howe to the south in order to control the Hudson and Mohawk Rivers, important avenues of transportation. Troops were quartered in Albany, and the countryside was scoured for supplies.

After Burgoyne surrendered at Saratoga in October 1777 and Howe was bottled up in New York City, the focus of the war shifted southward, leaving Albany and its environs cut off from their normal source of supplies via the Hudson River and New York City. While not directly threatened by the war, residents became constantly alert to threats from Loyalists and had reason to fear Indian attack. The Albany County Commissioners for Conspiracies, established on April 13, 1778, began to investigate Tories, Tory plots and rumors of plots. Life in Bethlehem had a definite siege mentality.

When peace finally broke out, Simion Baldwin, a young man and teacher at Albany Academy, wrote about it in his diary entry dated March 26, 1783:

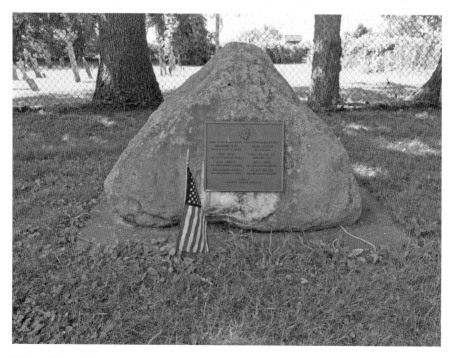

Eight soldiers of the American Revolution—Cornelius Glen, Hugh Jolly, Zimri Murdock, Francis Nicoll, James Selkirk, Richard Sill, Caleb Smith and Arie Van Wie—are buried at the small cemetery on Dinmore Road. *Courtesy of the author*.

Heard the glorious news of a general peace among the belligerent powers of Europe and America. It was brought by express into Albany. The people by the crier were desired to meet at the City Hall immediately. The letters were read and 3 cheers universally given. Other demonstrations of joy were suspended till official accounts should come to hand. No place on the continent which is so far from the enemy is so immediately affected as this; shut out from any sea port; trade, their dependence entirely stagnated and the most affluent families reduced to poverty. It does one good to see the general joy, which sparkles in the eye, enlivens the countenance, animates the feelings of all.

Three weeks later, Baldwin wrote of the official celebration that took place in Albany. One wonders how many Bethlehem folk made the trek to Albany to join in the festivities:

In the beginning of the evening fire was set to a large pile of piece wood prepared for the purpose, round pole with a large barrel of tar on the top. It made a beautiful appearance. We had no proper fireworks of powder. Some were drunk; many were merry; all were happy. The city was illuminated till 11 o'clock and appeared very beautiful, during which the streets were crowded with people.

Revolutionary War Connections

Three Families

The Haswell Family

In 1964, Samuel V.B. Haswell was interviewed by a woman named Marcy. A carbon copy of the transcript is filed in the Bethlehem town archive. Haswell was a descendant of John Haswell (1728–1808), who came here from England with his wife, Mary Hiliday (1740–1824), and several of their children aboard the ship *Golden Gate*. John Haswell rented three hundred acres from the patroon in Bethlehem near today's Haswell Farms development on Feura Bush Road. The old white farmhouse at the entrance to the development was built by his son William around 1820. Samuel V.B. Haswell farmed this property for more than fifty years beginning in 1915.

Following is an excerpt from Samuel V.B. Haswell's interview regarding the American Revolution:

> *Haswells did not fight in Revolution, but often times the officials of Colonial committees came around and asked for money for the cause. Haswell gave money when he was asked for money and had none he took off his coat and offered that instead of money.*
>
> *One of early Haswell men mentions in some correspondence the following: Rangers were a home military unit during the Revolutionary War for home protection against Tories and Indians. Tories had a camp and rendezvous near the banks of the Vlaumenskill in Mead's Lane. Tories plundered and burned, stole cattle, sometimes disguised themselves. Beckers*

were Tories so this writer says. Hans Burhans discovered the Tory camp in a grove of trees near Mead's Lane. Hans Becker threatened him. Burhans did not dare say for a long time what he had see for fear of reprisals.

COLONEL FRANCIS NICOLL

Francis Nicoll was a well-to-do, well-connected resident of Bethlehem. Bethlehem at this time was the small community that formed near where the Vlomankill empties into the Hudson River. Settlement here goes back as early as 1632, when a sawmill was established taking advantage of the water power found on the creek.

Francis Nicoll was born in 1737, the son of Rensselaer Nicoll and Elizabeth Salisbury. His father was a nephew of Kiliaen Van Rensselaer, the fourth patroon. It was through Rensselaer and his mother, Anna Van Rensselaer Nicoll, that the 1,300-acre estate at Bethlehem became separated from the much larger patroonship of Van Rensselaer Manor.

Rensselaer and Elizabeth Nicoll's two-story Dutch-style home, built circa 1735 and still standing today in Cedar Hill, became the hub of the social scene, and the Nicolls were known for their lavish hospitality. They were connected with the Van Rensselaers, Schulyers and other prominent families up and down the Hudson River. Son Francis, born and raised at Bethlehem, carried on that tradition. He married Margaret Van

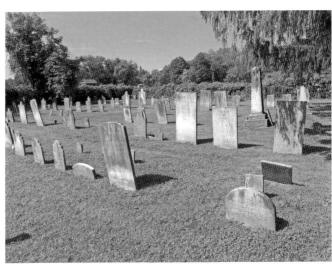

The graveyard at the end of Dinmore Road in Cedar Hill is the final resting spot of both Colonel Francis Nicoll and Sergeant James Selkirk. *Courtesy of the author.*

Rensselaer, a distant cousin. They had three children, with only daughter Elizabeth surviving to adulthood.

Francis Nicoll was active in the agitation in Albany County leading up to the Declaration of Independence. In 1775, he was a delegate to the Albany Committee of Correspondence and became a lieutenant colonel of the militia. He was elected to the Provincial Congress in 1775 and 1776. In November 1775, he was in New York City with the Congress debating New York's support of Boston. That winter found him escorting cannons upriver from New York to Albany, and by June 1776, he was made a full colonel. Nicoll assisted in supplying provisions to the Continental army, but by June 1778, he had resigned his commission to devote time to his family and their estate at Bethlehem. Nicoll died in 1817 and is buried in the family cemetery in Cedar Hill located across the road from the old Bethlehem House.

SERGEANT JAMES SELKIRK

Born in 1757 in Scotland, James Selkirk sailed to the colony of New York in 1774 aboard the *Gale*. In December 1775, he was living in Galway and enlisted with Colonel John Nicholson's Continental Regiment of New York Militia. Selkirk spent most of his first term of service in ill health, later mustering out at Albany. At the urging of a friend who valued Selkirk's ability to read and write, Selkirk reenlisted in December 1776 as a quartermaster sergeant under Colonel James Livingston.

Selkirk saw action at two key battles of the war, Saratoga and Yorktown. Below is an excerpt from his memoir about his regiment's arrival at Bemis Heights, Saratoga, New York, in September 1777:

We arrived at Schenectady, from thence to King's Ferry and waded the Mohawk above the ferry, hastened on to Stillwater and arrived at Bemis Heights and pitched our tents, a large army being collected of continental troops and militia from all quarters. We were now within a little distance of the enemy and our duty became very severe. We were ordered to keep everything in readiness as necessity called either to fight or retreat. Almost every day we had to strike our tents and load our baggage wagons, and in the evening to pitch them again. We had to lie with our guns in our arms and be ready at a moment's warning. We were turned out on patrolling parties every night to go through the woods and along on roads towards

the enemy with as great silence as possible to listen if we could hear anything like the sound of men, for we were suspicious that they would flank us. Our duty was so hard at this time that a sergeant said to me one day that if we were to be harassed long in this manner he would rather die than live and hoped he would be killed the first battle he went into. He had his wish accomplished.

The destination Selkirk describes below is Morristown, New Jersey, where General Washington had his headquarters in the winter of 1779–80. Selkirk's regiment arrived there in January 1780, having marched from Bristol, Rhode Island. That winter at Morristown was more severe than the more famous winter at Valley Forge.

It was late in the fall and cold weather shoes were worn off our feet with such a long and tedious march. At length we arrived at our destination where the army had been some time. They had all their huts built and was pretty well secured for winter. We pitched our tents in the woods till we could build huts, but an uncommon deep snow fell almost even with the fences and prevented our building them and we were obliged to keep our tents until the seventeenth of February when we had got the logs of our huts up and one side covered. We moved into them for we were almost perished in the tents. The winter was extremely cold. We suffered more this winter with cold, hunger and nakedness than ever we experienced before. I will attempt to give my readers a faint idea of it.

I need scarcely remind you that we lay in tents in very deep snow, very poorly clothed and but few old blankets to cover us. We had enough to keep ourselves from freezing. Add to this we seldom ever drawed our allowance of provisions and very often we had none at all. When we complained to our officers of our suffering so much with hunger they told us the roads was so bad on account of the snow being so deep provisions could not be got forwards to the army, when in short there was little provision to be forwarded, for this was the case of winter. Our officers were mostly gone home on furlough or had taken up their quarters in the farm houses for miles around in the vicinity of our camp so that a poor soldier had no chance to beg or buy a morsel. Those of the officers of our regiment who remained in the tents with them had to suffer as well as the soldiers. Some had to pick up the bone of the meat that had been thrown away and boil them over again to get some soup to keep them from starving. I know one man, a major's waiter, that ate some candles they had drawn and he got very sick.

James Selkirk received his discharge, signed by George Washington, from the Second Regiment of New York on June 7, 1783. He also received a Reward of Merit for a total of six and a half years of service.

After the war, Selkirk made his way to Bethlehem, where the Henry family was living. He had made the crossing from Scotland with them years ago. Selkirk married Elizabeth Henry on January 12, 1786, and settled in what is now the hamlet of Selkirk. Selkirk was a farmer and tailor and, with Elizabeth, raised a family of ten children. He died on December 2, 1820.

Chapter 26

REVOLUTIONARY WAR MARKERS

This article was published in the June 2015 edition of Our Towne Bethlehem.

As you travel though Bethlehem, have you noticed the signs marking the burial site of a "soldier of the American Revolution"? There are eight signs, five of which are the eye-catching blue and yellow of New York State historic markers. Eighteen veterans are memorialized. All of these signs were placed by the Tawasentha Chapter of the Daughters of the America Revolution (DAR).

Lieutenant John Leonard's sign is found in front of Hamagrael Elementary School. According to the DAR's records, Leonard was born in 1739 in Wittenberg, Germany. He married Cornelia Rechter on August 29, 1767.

Leonard served in the Fifth Regiment of the Albany County Militia, becoming a lieutenant on March 4, 1780. The Fifth Regiment was under the command of Colonel Gerritt G. Van Den Bergh. Leonard saw duty with familiar Bethlehem names like Captains George Hogan, Teunis Slingerland and John Van Wie and enlisted men Walter Becker, Joseph Haswell and John Oliver.

A glimpse into Leonard's service with the militia is found in John Flansburgh's sworn affidavit when he applied for a war pension in 1833:

> In the summer of the year 1780, this declarent then being appointed a sergeant in said company of which was still commanded by the said Capt. Hogan—Marched…on a tour of duty to Schoharie and was there

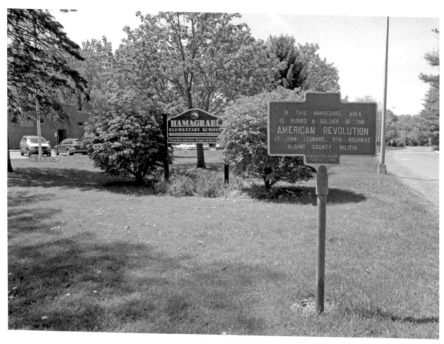

The historic marker in front of Hamagrael Elementary School on Mcguffy Lane in Delmar marks the nearby burial site of Revolutionary War veteran John Leonard. *Courtesy of the author.*

stationed at the Stone Church which was used as a Fort—Remained there some weeks when he was detailed under lieutenant John Leonard to assist in carry up new prisoners from Schoharie to Albany.

Today, the Old Stone Fort in Schoharie is a museum. As noted by Flansburgh, it was built as a church in 1772 and, with the beginning of the Revolution, was fortified in 1777. After 1778, various units of the Albany County Militia served garrison duty there.

While Flansburgh details several tours of duty in his application, we have no such information for Leonard. Leonard died on October 7, 1801, and was buried in the family cemetery. The exact spot is unknown, with the DAR indicating that it was on the Patterson farm, which was originally leased by the Leonard family in 1786. The Patterson farm was later developed by Edwin Heinsohn as Hamagrael Park in the area of today's Jordan Boulevard, Winne Road and Roweland Avenue.

Andrew Conning's snappy yellow and blue marker stands on New Scotland Road at the corner of Couse Lane in Slingerlands. He is noted

as having served under Captain Vanderheyden with the Third Regiment of the Albany County Militia. Conning was born in 1747 and died in 1827. His first wife had the last name of McBride, and his second wife was Betsy Wood (1762–1827). Both are buried at the family cemetery just down Couse Lane.

Patrick Callanan's small brown marker is in South Bethlehem at the entrance to Mount Pleasant Cemetery. He also served under Captain Vanderheyden with the Third Regiment of the Albany County Militia. Callanan died on October 4, 1824, at age eighty-nine. His wife, Susan, died on February 21, 1816, at age fifty-three.

The Callanan family is well known in South Bethlehem from the farmstead at Callanan's Corners to Callanan's quarry. The quarry is part of Callanan Industries, which was established by Patrick's great-grandson Peter Callanan in 1883 as the Callanan Road Improvement Company.

During the Revolutionary era, all males between sixteen and fifty (later in the war this was extended to sixty) were required to enroll in the local militia. Terms of service were usually three months, although New York could call out the militia for a few weeks several times a year if desired. Men appear to have served in different regiments at different times. For example, Leonard served under both Vanderheyden's Third Regiment and Van Den Bergh's Fifth. At the time, regiments were known more by their commanding officer than by their number. Albany County had seventeen such regiments. Keep in mind that at the time Albany County was much larger than it is

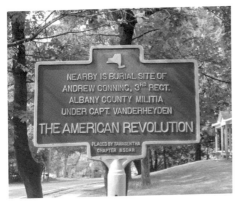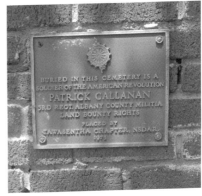

Left: A historic marker located on New Scotland Road at the corner of Couse Lane in Slingerlands notes the burial site of Revolutionary War veteran Andrew Conning. *Courtesy of the author.*

Right: A plaque at the entrance to Mount Pleasant Cemetery in South Bethlehem notes the nearby burial site of Revolutionary War veteran Patrick Callanan. *Courtesy of the author.*

today. It included the modern counties of Rensselaer, Saratoga, Schoharie, Schenectady, Greene and Columbia. All of these had been separated from Albany by 1800.

When called up, soldiers were expected to be armed and provide themselves with a blanket, powder horn and flint. The pay was twenty-six dollars a month for lieutenants and six dollars a month for privates.

All three men—Leonard, Conning and Callanan—are listed in the book *New York in the Revolution as Colony and State* as having land bounty rights in compensation for their service with the Albany County Militia. New York's militia troops were paid a rate equal to that of the Continental army troops, and a treasurer was appointed by the Provincial Congress in 1775 to collect revenues and pay New York's bills. Actual funds, however, were often lacking. In 1781, this lack of compensation for war service led to the establishment of land rights. A system was developed where rights to unappropriated land (a right being five hundred acres) were granted according to rank. More research needs to be done to determine if Leonard, Conning or Callanan exercised their land bounty rights.

Chapter 27

BETHLEHEM CONNECTIONS

Civil War Soldiers and Sailors

The Civil War (1861–65) was a seminal era for the United States, the state of New York and the town of Bethlehem. Over 2,750,000 soldiers and sailors fought for the North or South during the war. About 449,000 of them were from the state of New York. Over 350 of those have a Bethlehem connection.

The question is, how do you define Civil War soldiers and sailors "from" the town of Bethlehem? Were they born, enlisted, lived, died or buried in the town of Bethlehem? Or perhaps some combination of these factors? Men have been identified who fit all these categories. A few of their stories are highlighted here.

BETHLEHEM CONNECTIONS TO THE 177TH NEW YORK INFANTRY

The 177th was organized at Albany under Colonel Ira W. Ainsworth and left New York on December 16, 1862, for New Orleans assigned under the Third Brigade of Sherman's division. It took part in skirmishes at McGill's Ferry, Pontchatoula, Civiques Ferry and Amite River and was active throughout the siege of Port Henry. The 177th mustered out at Albany on September 24, 1863. Only 8 were killed or mortally wounded in action; 152 died of disease.

Several with Bethlehem connections served with the 177th, including the Carknard brothers, Andrew and Joel. Sons of Robert and Catherine

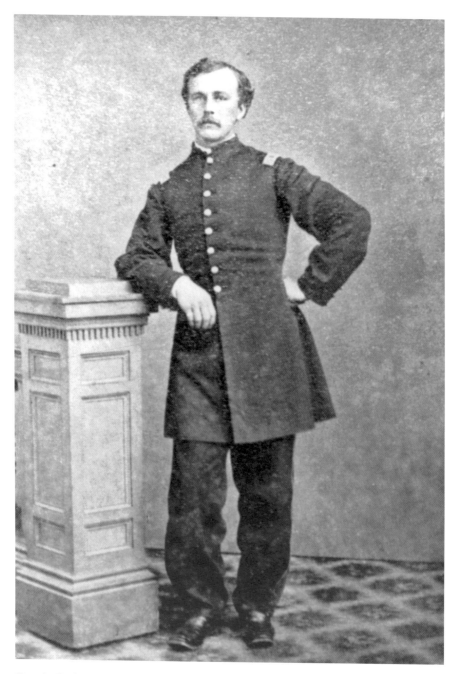

Captain David Burhans commanded Company H of the Forty-third New York Infantry. He was killed at the Battle of Po River while carrying the regimental colors on May 10, 1864. *Courtesy of Bill Howard.*

Carknard of Bethlehem, Andrew and Joel enlisted in Company I in October 1862. Both died of disease the following spring in Bonnet Carre, Louisiana, and are buried there.

William Slingerland, the son of John I. Slingerland and Sarah Hall, also enlisted in October 1862 in the 177th New York Infantry. A farmer, Slingerland was eighteen years old when he enlisted. He mustered out with the 177th in September 1863. His post office was listed as Norman's Kill, a hamlet in town soon to be known as Slingerlands. Slingerland's 1928 death notice in the *Altamont Enterprise* notes he had always lived in the hamlet and was its oldest resident. He was a retiree of the American Express company.

A poignant Bethlehem connection is the story of James A. Scrafford. He came to his grandfather's home in Bethlehem to die. Scrafford was born in Guilderland and went to Louisiana with the 177th. There he took ill, and his family made arrangements to bring him home. He arrived extremely ill in Albany on August 21, 1863, and died a week later at the home of his grandfather William Scrafford, Esq. The Scrafford family in Bethlehem ran a hotel in Elsmere near today's Mason Drive.

BETHLEHEM CONNECTIONS TO THE TWENTY-SIXTH INFANTRY, U.S. COLORED TROOPS

One wonders if Jacob Jackson (age seventeen at enlistment) and Samuel Jackson (age twenty-two) were cousins. Both were born in Bethlehem. Jacob's parents were Samuel Jackson and Betty Holland. Samuel's were Anthony Jackson and Susan Harris. Jacob and Samuel enlisted at Albany on August 8, 1864, as privates in company H of the Twenty-sixth Infantry, U.S. Colored Troops, and were paid a bounty of $33.33. Both were discharged on August 22, 1865, "at Hilton Head, SC by reason of expiration of term of services." Samuel continued to live at Cedar Hill, while Jacob's post office was listed as Albany.

The Twenty-sixth Infantry, U.S. Colored Troops, was organized under Colonel William Sillman in February 1864. It served in the Department of the East until March 1864; in the District of Beaufort, South Carolina, Department of the South, until April 1865; and was honorably discharged and mustered out under Colonel William B. Guernsey in August 1865. During its service, the regiment lost by death 21 killed in action, 9 from wounds received in action, 104 from disease and 11 from other causes.

Others from Bethlehem who served in the Twenty-sixth include John Wright and Peter Dickson. Other Jackson family members who served are Robert, Robert H. and Jarred.

BETHLEHEM CONNECTIONS
TO WELL-KNOWN CIVIL WAR EVENTS

There is plenty of opportunity to research Bethlehem's connections to well-known Civil War events. Here are a tantalizing few with interesting connections. Lieutenant Robert G. Noxon, who was born in Bethlehem, died from wounds received at Gettysburg. David Burhans, who was from Bethlehem and formed up a company here, died on May 10, 1864, at Po River during the Battle of Spotsylvania Court House. Four Bethlehem men are known to have died at the Andersonville prison: David McCulloch, Matthew Shillford, John Stultz and Charles VanAllen.

Chapter 28

KISS CLARA FOR ME

The Civil War–Era Letter of Samuel West

As town historian, a favorite inquiry is the one that starts with "I've got some old letters I found in the attic. Do you want to take a look?" Mark Flood of Slingerlands uttered words to that effect. While renovating his home on New Scotland Road, he came upon a moldy, mouse-chewed pile of papers that included a Civil War–era letter from Samuel West. While admitting I am not a Civil War expert, I agreed to see what I could find out. As always happens with old documents, one question leads to another, and another, and another.

THE LETTER

Following is a transcript of the letter. In essence, it is written as one long stream of consciousness. I have kept Samuel's spelling but added paragraphs and punctuation for clarity. The letter is in an envelope addressed to "Mr. James H. West Clarksville Albany Co N.Y." and postmarked "Washington DC Oct 1, 1862":

> *Fort Pensylvania*
> *Sept 30, 1862*
> *Dear Father and mother*
> *I now take my pen in hand to let you know that we are all well at present and I hope that these few lines find you the Same. george got a letter from*

you and we was glad to hear that you was all Well. there is not much going on here now except drill and work on the new forts. we are putting up five new forts here within one mile from here. we work one day and then lay off one day then every Sunday we have general inspection and after inspection we have church and after that we can go where we are a mind to until ½ past five then we have dress parade then at ½ past eight we have tattoo and at nine the lights must be out. tattoo means roll call.

frank got a letter from hat day before yesterday. he sends his respects to you all. I am going to washington to morrow to get some leather for to make the lieutenant a pair of boots. he had a pair when he came out here but he found them to small and George got them of him. He give him $6 for them. they was sewed and a good pair at that.

I Suppose you get all of the war news as well as me but I See by the papers that Jeff davis wants to Settle this war and is going to Send three men to washington to arrange it. it dose not look So much like war as it did a short time ago but we will have it pretty Soon unless we have peace as it is said we will as the commissioners are in washington now to See if they cannot arrange it in Some way as they are getting tired of the fun about now. they see that we are getting to large an army now so they want to stop the fun. I seen of piece in the paper to day how they offer to settle it and is an honorable way so far as I can see it some old abolitionists will not like it may be but I guess that it will Suit the majority of us

no more at present. write as soon as you get this. Kiss clara for me. tell her to be a good girl. give my love to all. tell till to write me soon.
Samuel West
Privet Samuel West
Co H 113 Regt N Y S V
Washington DC

Opposite: The first page of the Civil War–era letter of Samuel West to his father and mother. *Courtesy of Mark Flood.*

NOT A STAR MUST FALL.

Fort Pensylvania
Sept 30 1862

Dear Father and mother
I now take my pen in hand
to let you know that we
are all well at present and
I hope that these few lines
will find you the same
george got a letter from
you and we was glad to
hear that you was all
Well there is not much
going on here now except
drill and work on the new
forts we are putting up
five new forts here within
one mille from here

Who Are the People?

My research started with the U.S. census. Taking my cue from the letter's addressee, I find in the 1860 census that James H. West (age fifty-one, shoemaker); his wife, Lydia A. (forty-four), and their daughter Harriet (fifteen) are living in Clarksville. A separate entry lists George West (twenty, farm laborer). Another lists Samuel West (twenty-two, shoemaker), Mary E. (twenty-two) and Clara (two) all living in Clarksville.

Ten years earlier, in the 1850 census, James and Lydia were living in Rensselaerville with their children Mary (age thirteen), Samuel (twelve), George (nine) and Henrietta (six). This confirms that James and Lydia are Samuel's parents, Harriet is his sister and George is his brother. Did you note in the 1860 census that Samuel West is married to Mary and their daughter is Clara? Clara would have been four at the time the letter was written. No wonder Samuel sends kisses her way.

Did you also notice that both Samuel and his father are shoemakers? That explains the part in the letter about getting "some leather for to make the lieutenant a pair of boots." The letter also states that "Frank got a letter from Hat." Perhaps Hat is Samuel's sister Harriet?

What About the 113th New York Infantry?

The next avenue of exploration is finding out about the 113th New York State Volunteers. New York's muster roll abstracts have both Samuel West and George West in the 113th. You might be curious to know that the muster roll abstract lists Samuel as five feet, four and a half inches tall with blue eyes, brown hair and a light complexion.

It only makes sense that Samuel and George were in the 113th. The regiment was known as the Albany County Regiment, and the men were recruited principally from Albany County, including New Scotland and Bethlehem. The regimental history at the New York State Military Museum has much information about the 113th, including the fact that while mustered in as 113th Regiment of Infantry on August 18, 1862, the unit was designated the 7th Regiment of Artillery (heavy) on December 19, 1862.

This key fact was instrumental in discovering the book *Carnival of Blood: The Civil War Ordeal of the Seventh New York Heavy Artillery* by Robert Keating. Keating's book conveniently has a complete roster in the back, including these two listings:

West, George—Born: Saratoga, NY. Age 22. Occupation: farmer. Enlisted: August 12, 1862, as private in Co. H: wounded, September 30, 1864, at Petersburg; mustered out, June 16, 1865, as artificer.

West, Samuel—Born: Watervliet, NY. Age: 21. Occupation: shoemaker. Enlisted, August 12, 1862, as private in Co. H; promoted corporal, August 18, 1862; sergeant, December 9, 1863; first sergeant, June 1, 1864; wounded, June 3, 1864, at Cold Harbor; captured, June 16, 1864 at Petersburg; paroled, February 27, 1865, at North East Ferry, NC; mustered out, May 21, 1865, from hospital at Albany, NY.

Did you notice the age problem? The book and the muster roll abstracts appear to have the incorrect age for Samuel. In 1860, he was twenty-two, so when he enlisted in 1862, he should have been about twenty-four. A check of the town clerks' registers of men who served for New Scotland or Bethlehem reveals no listing for either brother.

Remember Frank from the letter? Unfortunately, there are several Franks in the regiment roster, including Beardsley, Laurenaux, Shepard and Treadwell. Frank will have to remain a man of mystery.

The regimental history of the 113th/7th includes an assortment of newspaper clippings. One describes the sendoff the Albany County Regiment received when, on the evening of August 20, 1862, it received orders to embark on the steamship *Hendrick Hudson* at the Albany dock and head for points south: "Ten thousand men and women lined the streets through which the Regiment passed. No equally intense enthusiasm has marked the departure of any Regiment since the war began; and no finer body of men ever went to the tented field in any country."

Upon its arrival in Washington, D.C., the 113th was ordered to garrison various forts that were part of the defense of Washington, including Fort Pennsylvania (later renamed Fort Reno). Samuel's letter aptly describes life at the fort, including work on the fort, drills and inspections. The men were drilling on heavy artillery, hence their conversion in December 1862. The unit continued its work in Washington, D.C., until ordered to join the Army of the Potomac in May 1864. Its first engagement was on May 19 at Spotsylvania.

During the course of the war, the 7th saw action with the Army of the Potomac at Spotsylvania Court House, Wilderness, North Anna River, Cold Harbor, Petersburg (assault and siege), Deep Bottom and Ream's Station. The 7th was recalled from the front on February 22, 1865, to Baltimore, Maryland, and garrison duty. On August 1, 1865, the unit was mustered out and honorably discharged from service.

Its arrival in Albany was noted in the local newspapers:

The brave heroes of the Seventh Heavy Artillery arrived on the Norwich *about five o'clock this morning. The Steamboat landing was swarmed with friends of the Regiment. The Citizen's Committee were promptly on hand to care for their wants. Some of the boys, as soon as they landed, started for their homes; but the most remained, were formed into line, and marched up Broadway to Sate Street, through Pearl and Columbia streets to Broadway again, and down Broadway to Stanwix Hall. During the march, the sidewalks and streets were thronged with a dense mass of citizens.*

A total of 677 officers and enlisted men of the 113th/7th were killed during the Civil War, 217 "at the hands of the enemy" and the rest from disease and other causes.

What About the War News that Samuel Imparts?

It is interesting to note that on September 22, 1862, Abraham Lincoln made clear his intention to issue the Emancipation Proclamation on January 1, 1863. The proclamation was an executive order based on the president's powers as commander in chief of the army. In his letter, Samuel speculates that the war will be over soon and that the abolitionists will not be happy. Knowing about the proclamation, perhaps Samuel believes it will not be issued if peace breaks out, hence the unhappy abolitionists. As we know now, the proclamation was issued, and the war continued.

Then What Happened to Samuel?

After mustering out in May 1865, it appears that Samuel went home to Clarksville. Going back to the census, in 1880, it is clear that Samuel (age forty-two), boot and shoemaker, and his wife, Mary (age forty-four), are living in Clarksville. By 1880, Clara would have been twenty-two and probably not living at home. The 1892 New York census has Samuel West, age fifty-three, shoemaker, New Scotland.

How Did the Letter End Up in Slingerlands?

Lydia West, Samuel's mother, kept her son's letter when she moved away from Clarksville sometime before 1870. In the 1870 census, she is listed as living in Bethlehem Center. In 1880, Lydia A. West (sixty-three, keeping house) is listed along with Charles Simmons (twenty, son, laborer.) While the census record indicates Bethlehem Center, Lydia's dwelling is clearly in the hamlet of Slingerlands. Living just a few doors down are Albert and Catherine Slingerland (and their daughter Leah Haswell), prominent property owners in the hamlet.

A mystery is why Lydia's "son" Charles Simmons does not have the same last name. He would have been born in 1860 (when the census has her living with husband James H. West in Clarksville). The 1860 census also has a William Simons, age thirty-three, and his son Charles, age three months, living in Clarksville. Possibly, Lydia's maiden name was Simmons, with William being her brother.

By the 1900 census, Charles Simmons, age forty, is living in Slingerlands with his wife, Mary, and children William D. and Zelda. And indeed, Samuel West's letter was found among other papers that relate to the Simmons family. Therefore, further research will likely determine that Charles Simmons was one of the owners of Mark Flood's home.

Notes on Doing Research

In this day and age, finding the information in this article is more accessible than you might think. Here are the ways I went about it from the comfort of my own home.

The Bethlehem Public Library makes an enormous amount of information available on its website (bethlehempubliclibrary.org). Click on the research tab for a listing. I used Heritage Quest to access census records. Ancestry is available for free if one is physically in the library. (I bring my laptop and a cup of coffee and sit at the café tables in the hallway.) Ancestry's New York records are available for free to New Yorkers through the New York State Archives web page (archives.nysed.gov). With a little Internet savvy, one can browse both the town clerk's registers of men who served in the Civil War and New York's muster roll abstracts.

The New York State Military Museum has a wonderful website with detailed information, including its New York State Unit History Project. Simply go to its website (dmna.ny.gov/historic/mil-hist.htm) and click on Civil War Units.

Chapter 29

THE CEDAR HILL ARMY OBSERVATION POST

This article was originally published in the June 2013 issue of Our Towne Bethlehem.

The United States entered World War II after the bombing of Pearl Harbor on December 7, 1941. Soon the whole country was involved in the war effort. On February 17, 1942, Bethlehem's town board appointed a Defense Council to see to local defense and civilian mobilization. Volunteers, both men and women, were registered and assigned to various divisions, including wardens, medical, radio, messengers, home nursing, nutrition and salvage. The Bethlehem War Council's final report notes that about 870 men were registered. This does not include the men assigned in Selkirk and South Bethlehem. They worked through the Ravena-Coeymans Council, due to "telephone difficulties." About 800 women registered, again not including Selkirk and South Bethlehem.

Defense activities included conducting blackout drills, surveying emergency feeding and billeting stations, establishing air raid shelters and emergency hospitals and providing radio and messenger services. Mobilization activities included keeping track of all the necessary records, securing volunteers for rationing, setting up a block leader system, running the salvage drives and coordinating childcare for working mothers.

Amid all this local activity, the U.S. Army Air Force was organizing its Ground Observer Corps. Twelve observation posts were established in Albany County, with three of them claimed by the Bethlehem War

People gather under the American flag at the Cedar Hill Army Observation Post. Notice the large horn-shaped amplifying device used to listen for enemy aircraft. *Courtesy of the Town of Bethlehem.*

Council in its report. One was located at the Game Farm (now Five Rivers Environmental Center and actually in the town of New Scotland), one at the Albany Municipal Golf Course (this area was annexed by the City of Albany in 1967) and one at Cedar Hill.

The Cedar Hill Army Observation Post was established in August 1942 on the roof of the carriage house of the Hudson River estate built by George Best in the 1880s. The location near the river was ideal, as enemy aircraft were apt to follow the water routes to inland targets. Today, the carriage house is a private home near Henry Hudson Town Park.

The post was manned by volunteers, including Chief Observer Thomas Finley and Assistant Chief Esther Hillman, twenty-four hours a day, seven days a week to listen and watch for enemy aircraft. A large horn containing an amplifying device helped listeners distinguish aircraft sounds from other noise, especially passing trains. Volunteers received special training in visual aircraft recognition.

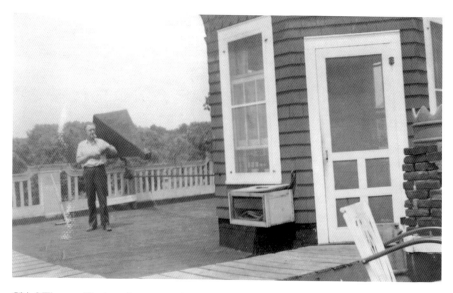

Chief Thomas Finely strikes a casual pose on the rooftop observation post. *Courtesy of Elizabeth Hillman-Seronda.*

When the war ended in the spring and summer of 1945, Bethlehem's War Council wrapped up with its final report. Many of its duties continued with the civil defense and emergency preparedness efforts of the 1950s.

AIR OBSERVER JEAN STEPHANY KLEINKE

Jean Stephany grew up in Cedar Hill. Her family owned Folly Wick, a historic house located on what is today known as Lyons Road, just a stone's throw from the carriage house that would house the Cedar Hill Army Observation Post. She attended the local Cedar Hill school for her primary years and headed to Coeymans for high school. Jean enjoyed the Cedar Hill Busy Beavers 4-H Club along with Esther Hillman. It was her friend Esther who urged Jean to volunteer at the observation post.

In conversation, Jean remembered the training provided to identify the silhouettes of aircraft. Even now she could recognize the distinctive tail of the B17 bomber. Volunteers served a "two-hour trick" at the post, and Jean reports that it was pretty quiet. One bit of excitement was when the army flew an exercise low over the Hudson River. Jean served at the observation post from about 1944 through the end of the war.

Jean married Edward S. Kleinke on September 27, 1947, and moved to Maher Road in Slingerlands. She has lived there ever since and has been a lifelong participant and leader with the 4-H. It was Ed's parents who owned the eponymous Kleinke's farm on Kenwood Avenue in Delmar.

4-H is a youth development program represented in Albany County by the Cornell Cooperative Extension. The four Hs are head (managing, thinking), heart (relating, caring), hands (giving, working) and health (being and living).

Part VI

EARLY BETHLEHEM

Chapter 30

BOUNDARY LINES

This article is adapted from a presentation Anthony Opalka, Albany city historian, and I gave to the Bethlehem Historical Association in the fall of 2014.

Since its establishment by the State of New York on March 12, 1793, Bethlehem's town line has been anything but static. To the west, Clarksville, New Scotland, Feura Bush and Vorheesville all used to be part of Bethlehem. To the north, Albany south of Third Avenue including Cherry Hill, Kenwood, the port of Albany, Whitehall, Hurstville and even Buckingham Pond were included as well. So how did Bethlehem get the shape it has today?

It all started in 1629, when Killiaen Van Rensselaer, a wealthy Amsterdam merchant, was granted the title of patroon of Rensselaerswyck. Soon thereafter, his agents made the first purchase from the Native Americans and brought the first settlers to what was to become Bethlehem. By the time they were done acquiring land in the 1660s, the Van Rensselaer family controlled approximately 770,000 acres on both sides of the Hudson River. Imagine Fort Orange/Beverwyck/Albany as the hole in the middle of a donut, independent from the patroon's manor. The Dongan Charter of 1686 formally established the city of Albany and its boundary line with Rensselaerswyck Manor. On the Bethlehem side, imagine a line running roughly from Third Avenue straight on out northwest to today's Guilderland.

In 1772, Albany County was established with the future Bethlehem still "on the Manor." In 1788, the West Manor was recognized as the town of

Watervliet, and it included all of modern Albany County except the city of Albany and parts of Niskayuna. The law carving the town of Bethlehem out of the town of Watervliet was enacted on March 12, 1793, and took effect on the first Monday in April 1794. The new town line abutted the city of Albany and town of Guilderland to the north, the town of Rensselaerville to the west and the town of Coeymans to the south.

On April 25, 1832, the New York state legislature passed an act that divided the town of Bethlehem in two. A line six miles inland that runs parallel to the Hudson River was established creating the town of New Scotland on the west side. Basing the line on the Hudson River sometimes proved problematic, what with the shifting shorelines of this natural feature. Howell and Tenney's *Bi-Centennial History of Albany County* notes that no records survive of the surveyors who established the line and that "of the trees marked by the surveyors as monuments in this division line many have been wantonly destroyed, and the few remaining will soon disappear."

As time marched on, Bethlehem continued as a rural, agricultural town, except in the northern portion that abutted the city of Albany. Residents of Kenwood and Groesbeckville, today in the area of Second and Third Avenues and Delaware Avenue, and on the west including the Academy Road area and Hackett Boulevard, desired city services and felt they fit in more with city life. This area was annexed by the city in 1870.

Forty years later, in 1910 (and re-ratified in 1916), the boundary line was brought down to the Normanskill in the Kenwood and Normansville area, except for Graceland Cemetery. It also established the Krumkill as part of the boundary line, taking in the north side of Whitehall Road and the Buckingham Lake area. Westerlo Island, now the Port of Albany, was annexed in 1927.

In 1938, before beginning its new development called Golden Acres, the Picotte Building Company petitioned to have the property annexed to the City of Albany. It wanted water and sewer services for its proposed apartment buildings and single-family homes. This small annexation encompassed Crescent Drive, Berncliff Avenue and Home Avenue, all of which are just off New Scotland Road.

The contentious annexation of the Hurstville and Karlsfeld section began gently enough when residents petitioned in August 1962 to join the city. While the area of eighty-two acres was described as mostly rural, residents wanted city services. Bethlehem's supervisor, Bertram Kohnike, and the town board began the fight against the annexation, not wanting to lose territory and taxpayers to Albany. The annexation movement only grew, with an even

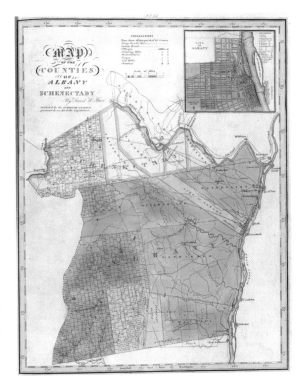

Right: Burr's 1829 map of Albany County shows Bethlehem when it was roughly twice the size that it is today. *Courtesy of the David Rumsey Map Collection.*

Below: This portion of Beers's 1866 map of Bethlehem illustrates the town's northern border before Albany's 1870 annexation. *Courtesy of the author.*

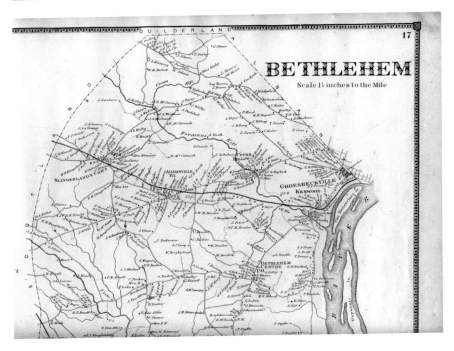

larger group petition presented in July 1964 that proposed annexing over one thousand acres.

The *Albany Knickerbocker* newspaper reported in its September 6, 1964 issue that Bethlehem officials complained, "The city is gnawing away at town land and possibly planning to swallow up all of North Bethlehem eventually. Residents are being romanced by the lure of its [Albany's] services and tax promises." Part of the lure was Mayor Corning's promise to not raise property assessments for five years. Finally, after unanimous approval by a special three-judge tribunal appointed by the appellate court, residents saw the success of their "See You in Albany" campaign in August 1967.

The year 1976 saw the completion of the modern-day boundary line between Bethlehem and Albany. Graceland Cemetery was annexed and the Normanskill established as the line.

SO WHAT HAPPENED TO RENSSELAERSWYCK MANOR?

Despite the creation of towns, Rensselaerswyck Manor continued into the 1840s and '50s.

In the early days of the Dutch colony, the Van Rensselaers offered settlers and tenants short-term leases. With the English takeover from the Dutch in 1664, the Van Rensselaers fought to protect their manor and the investments and income it produced. In 1685, the royal governor, Thomas Dongan, issued a patent for the manor, or patroonship, of Rensselaerswyck. It specifically excluded Albany. As noted previously, the City of Albany received its charter from Dongan the following year.

About this time, in order to increase profits, the patroon began to offer lifetime leases. While the lessee "owned" the property in the sense that he could bequeath it to his children, divide and sell it and attain voting rights based on his ownership, at the same time he also "rented" the property and owed an annual payment to the patroon. Rents were usually paid in fat fowl, bushels of wheat and a day's labor with a team of horses.

The Van Rensselaers continued to lease farms and collect rents on the manor into the early 1800s, gradually filling in the wilderness westward from the Hudson River up into the Helderbergs and the hill towns. Remember, their holdings stretched roughly twenty miles inland from the river.

This feudal-like system came to a head in 1839 with the death of Stephen Van Rensselaer III, the eighth patroon. His will directed that all unpaid rents

be paid immediately, and his heirs set about trying to collect. The rents, and especially any back rents that were owed, were a heavy burden to tenants in the hill towns of Berne and Knox. Some tenants refused to pay, and the Anti-Rent War began.

There were armed confrontations between farmers and Albany County sheriffs trying to collect rents. Farmers and their families were forced off land that they had improved and farmed for years. During the 1850s, the legal status of the leases was confronted through the legislative process. In the end, while the Van Rensselaers' right to enforce the leases was upheld, there were few winners. Some tenants were able to buy out their lease from the Van Rensselaers. The family itself got out of the real estate business by selling a large portion of its holdings to Walter Church, a real estate speculator. Church, in his turn, often sold them back to the original tenants. Amazingly, other leases continued on, with rents due, even into the early twentieth century.

Chapter 31

NATIVE AMERICANS, HENRY HUDSON AND THE FIRST BETHLEHEM IN BETHLEHEM

Traveling down Dinmore Road in Cedar Hill, following the wafting aroma of the wastewater treatment plant, one comes to a lovely old brick home, a historic cemetery and a sweeping expanse of open land. This is a spot in town that brings together a remarkable era in history (OK, not the treatment plant—nothing remarkable about that): the early 1600s.

Native Americans had an active presence in what was to become the town of Bethlehem for thousands of years. In the early 1980s, the Bethlehem Archaeology Group, led by Floyd Brewer, carried out extensive archaeology work in the Dinmore Road area, finding artifacts that date as early as 6500 BC. Over those many years, occupation ebbed and flowed, with a significant peak from 2500 to 1400 BC. Signs of village life from this period include numerous projectile points and the weights, or banner stones, that were used with the throwing sticks that are known as atlatls. The throwing sticks, tipped with stone projectile points, provided added velocity and power that enhanced the hunting of deer and other game. The stone net sinkers that were found give evidence of fishing activity on the nearby Hudson River.

Brewer and crew also found much evidence of Mohican Indians dating to after AD 1000, the late Woodland period, and on into the Contact era. Indications of a large village in the Goes Farm area at the end of Dinmore Road were found as well.

Another name for the Mohicans—*Muh-he-con-ne-ok* or People of the Waters that Are Never Still—reflects their identity as river Indians. The waters of the Hudson River are doubly unstill. Even with the ocean about

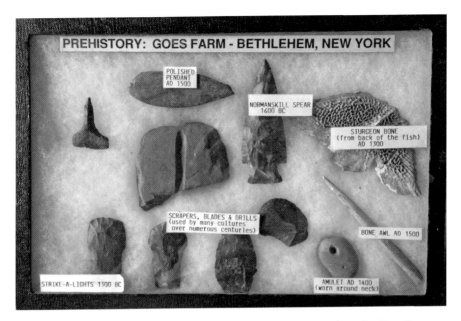

PREHISTORY: GOES FARM - BETHLEHEM, NEW YORK

POLISHED PENDANT AD 1500

NORMANSKILL SPEAR 1600 BC

STURGEON BONE (from back of the fish) AD 1300

SCRAPERS, BLADES & DRILLS (used by many cultures over numerous centuries)

BONE AWL AD 1500

STRIKE-A-LIGHTS 1300 BC

AMULET AD 1400 (worn around neck)

A selection of Native American artifacts, plus an old sturgeon bone, from the Goes Farm site are arranged for study. *Courtesy of the author.*

150 miles away, the river is essentially a tidal estuary. The water flows in two directions depending on which way the tide is going. Circa 1600, Mohicans controlled a wide swath of territory on both sides of the Hudson River, including modern-day Columbia, Rensselaer and Washington Counties on the east side and Greene, Albany, Schenectady and Saratoga on the west. Their influence extended into parts of western Massachusetts and Vermont.

When Henry Hudson was in the Bethlehem area* in September 1609, he had peaceful encounters with the Native Americans. As Shirley Dunn notes in her book *The River Indians: Mohicans Making History*, the Mohicans influenced history by simply not murdering Hudson. As Dunn writes, "They could so easily have reacted with fear, let loose a shower of arrows, and looted the ship."

Hudson was the English explorer who sailed for the Dutch aboard the *Half Moon* on the hunt for a fast passage to the Far East. His report back to the Dutch West India Company about the northern reaches of the river

* I am casting a wide net here—there is much discussion about where Hudson had this encounter with Mohican Indians. I recommend Chapter 1, "Saving Henry Hudson," of Dunn's *The River Indians* for a thorough analysis.

with its countryside rich in natural resources like timber, beaver and fertile soils, plus friendly inhabitants, directly led to early settlement in what was to become Bethlehem. Dutch traders came and established Fort Nassau in 1614 on Westerlo Island (today's Port of Albany), which, by the way, was in the town of Bethlehem until 1927. Fort Orange, Beverwyck, Rensselaerswyck Manor and the city of Albany soon followed.

The first appearance of the place name Bethlehem occurs in Court of Rensselaerswyck records. According to *Bethlehem Revisited*, a court ruling on January 21, 1649, states that Andries deVos is to pay the patroon's dues on his mill at Bethlehem. The reference is to the community that formed near the confluence of the Vlomankill and the Hudson River. Water from the Vlomankill powered the mill, and the alluvial soils provided rich farmland. Today, this is in the vicinity of Henry Hudson Town Park and Dinmore Road.

Also of interest is the next occurrence of the name Bethlehem in the court records from late 1649. As recorded in *Bethlehem Revisited*, Aert Jacobson is a neighbor of deVos who is farming north of Vlomankill near the northern end of today's park.

> *Gerrit van Wencom declares that a certain Mahican, whom he* [found] *at* [Aer]*t Jacobsen's, at Bethlehem, on Wednesday, the 8th of December 1649,* [said Indian] *being quite drunk with anise water, assaulted and fell upon him in cold blood and almost strangled him, in such a way that his head was extremely swollen, but that he was accidentally released by another Indian.*

One wonders about *that* story.

The lovely brick home at the end of Dinmore Road is known as Bethlehem House, reflecting the name of the early settlement here. It is also known as the Nicoll-Sill House and was the home of Revolutionary War veteran Francis Nicoll. It was built by his parents, Rensselaer and Elizabeth Nicoll, in 1735. Across the street from the home is a burial ground enclosed with a vine-draped chain-link fence. Over seventy-five people were buried here, starting in 1743 with Rensselaer and Elizabeth's infant daughter, Frances, and ending in 1876 with the burial of their great-great-grandson William N. Sill. Beyond the fence are the fields where a Mohican village used to lay, including a Native American burial ground.

Today, the Nicoll-Sill House is privately owned and the First Reformed Church of Bethlehem has charge of the cemetery. In recent years, the

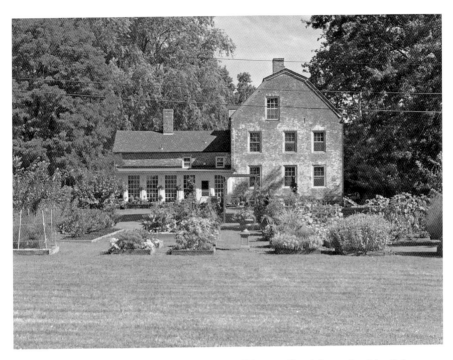

A modern view of Bethlehem House taken from Dinmore Road shows the side of the house with its Dutch gambrel roofline. The front of the house, to the right in this picture, is oriented toward the Vlomankill and Hudson River. *Courtesy of the author.*

Stockbridge Munsee Band of the Mohican Indians has purchased the sacred ground of the Native American burial site and the associated acreage of the former Goes Farm. Their purchase brings the story of the land at the end of Dinmore Road full circle.

ENDNOTE

Mohican, Mahikan, Mahiecan, Maykan, Muhheakunn, Moheakun, Mohegan, Mahican, Mahikander—you will see the name for the Native American population present in our area in the early 1600s spelled many ways. I choose to use Mohican because that is how their descendants choose to refer to themselves: the Mohican Nation. And please, don't be confused by James Fenimore Cooper's famous book. There never was a last Mohican. Visit their website at www.mohican-nsn.gov and see for yourself.

Chapter 32

SLAVERY IN EIGHTEENTH- AND EARLY NINETEENTH-CENTURY BETHLEHEM

While the thought of slavery might make us uncomfortable, it was a reality in Bethlehem's early history. The following article, framed around a historic document, introduces the topic.

THE JOURNAL

Records of Bethlehem for the Purpose of Intering Negro Children Born of Slaves from this 4th Day of July 1799 is the name of a handwritten journal found in the town's archive. It is a record of births and manumissions that was created in response to the Gradual Emancipation Law of 1799. The first entry reads, "John Slingerland Being A proprietor of A Negro woman Slave which Said Slave head a Child Born on the tenth day of September 1799 Being a Boy Named Jhack."

The book goes on to list thirty-six such children born in Bethlehem between 1799 and the last birth entry made in 1821. Only two mothers' names were listed. Solomon D. Townsend registered the birth of Mary's child on September 17, 1819. On October 6, 1821, John L. Hogboom registered the births of Bett's three children: Mink (born January 29, 1813), Deyann (September 5, 1817) and Gin (October ?, 1820). One wonders why Bett's children were listed so long after their births. Most were listed within about six months.

Also recorded in the book are a series of manumissions, when slaves were set free. These are usually followed by a certification from the overseers of the

poor that the person is able to take care of himself, assuring that he will not become a burden on the town.

The first manumission is of Jack Jackson and reads:

> *I Wendell Hillebrant of Bethlehem in the County of Albany farmer do hereby manumit and set free my negro man slave named Jack Jackson aged about 45 years the said negro man being formerly the property of Phillip Fonin Junior this certificate being executed according to an act of the Legislature of this State entitled an act concerning slaves and servants Dec 17ᵗʰ 1810* [signed] *Wendel Hillebrant*

The front page of the book that records slave births and manumissions between 1799 and 1827 for the town of Bethlehem. *Courtesy of the Town of Bethlehem.*

Immediately following is this certification:

> *We William Radly and William Warren overseers of the poor of the Town of Bethlehem do certify that the negro man slave named Jack Jackson the property of Wendell Hillebrant described in the above article of manumission appears to be under the age of fifty years and of sufficient ability to provide for himself.* [signed] *William Warren, William Radly.*

Followed by: "I certify the above to be a true copy from the original Bethlehem 7 January 1811 [signed] John I Moak Town Clerk."

In all, thirty-five manumissions are listed in the book. Unlike Hillebrant's wording above, others insert the phrase "for good and valuable considerations" before the manumission statement. One wonders if the slaveholder is receiving payment and who is doing the paying. Per usual, old documents raise more questions than answers.

THE LAW

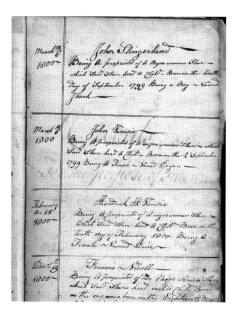

The first entry in the record book is dated March 6, 1800, and records the birth of Jhack. *Courtesy of the Town of Bethlehem.*

The Gradual Emancipation Law of 1799 decreed that all those born after July 4, 1799, were "free." Those born prior to that date remained enslaved. While seemly straightforward, the 1799 law was anything but. These children were required to serve an indenture during the prime working years of their life (until age twenty-five for women, twenty-eight for men). With indentures beginning as young as age four, no one was getting liberated anytime soon.

L. Lloyd Stewart, in his book *A Far Cry from Freedom: Gradual Abolition, 1799–1827*, provides an interesting discussion of the abandonment of these "free" children by their mothers' owners to the overseers of the poor. Subsequently, the overseers often placed these same children back with the mothers' holders, and the state paid them a monthly stipend for their upkeep until they could be bound out at age four. Records of abandonment have not been found in Bethlehem's archive.

In 1817, New York State enacted a law that stated those born before July 4, 1799, would become free on July 4, 1827. It also shortened the indenture period for those born after July 4, 1799, to twenty-one years. As Patrick Real in *Slavery in New York* sums up: "Since children born to slave mothers on the eve of July 4, 1827 could be apprenticed to the age of twenty-one, African Americans would remain unfree until 1848."

CENSUS RECORDS

Looking at census records, one can also glimpse Bethlehem's slave population. Prior to 1793, Bethlehem was part of Watervliet, and it is

difficult to tease out Bethlehem residents. A look at the 1800 census indicates that of a total population of 3,733, 254 were slaves and 13 were listed as "all other free persons except Indians." Those 13 can be found in the households of Cezar Wood, Titus, Jack and Robert. In 1810, there were 137 slaves and 109 "free colored persons"; in 1820, 72 slaves and 65 "free colored persons"; and in 1830, 0 slaves and 167 "free colored persons."

The drop to zero in 1830 reflects the 1817 law that "freed" the slaves by 1827. One wonders, however, what caused the drop in 1810 from 246 total African Americans to 137 in 1820. Where did they go? Were they undercounted? Were the enslaved sold out of Bethlehem? Did the free pack up and move? Again, more questions than answers.

A Closer Look at Bethlehem Resident John Hillebrant

John Hillebrant registered the births of four children of slaves: Annah (b. 1801), Jon (b. 1802), Mannas (b. 1803) and Will (b. 1805). He registered no manumissions in this journal. About this same time, records of the First Reformed Church of Bethlehem indicate that a John Hildebrant married Catharine Rosekranse on April 30, 1803. They had four children baptized at First Reformed, the first of whom is Anne, born on November 25, 1805.

Given the spelling habits of the time, tracing the name Hillebrant is challenging. In the 1800 census, there is a John Hillebratt listed with eleven people in his household, five of whom are slaves. In the 1810 census, there is a John Hellebrant with thirteen in his household, all of whom are "free whites." In 1820, there is a John Helebront with eleven people in his household, none of whom are slaves or "free negros."

Interestingly enough, also in 1820, there is a John Hellebrant listed in the census with only African Americans in the household. One is listed as a slave over the age of forty-five; the others appear to be a free "colored" man under the age of forty-five, two free females under the age of fourteen and one woman under twenty-six and one under forty-five, for a total household of six. Is one of these the Jon whose birth in 1802 is mentioned above?

ALWAYS MORE QUESTIONS

The reality of slavery in Bethlehem is clear from these records. Original documents found in the town's archives provide just a glimpse into the lives of Bethlehem's earliest residents, both enslaved and free. Readers are encouraged to read about Caesar, a slave on the Nicoll-Sill property in Bethlehem, in Allison Bennett's book *Times Remembered*. His daguerreotype portrait is on the cover of *Slavery in New York*, an excellent book that presents modern scholarship on the topic.

Part VII

SUMMER HOMES
AND SUBURBS

Chapter 33

THE MANSION AT CEDAR HILL

This article appeared in the January 2014 edition of Our Towne Bethlehem.

Always meant to have a party. That's how Danielle Marvelli describes her lovely River Road home in the Cedar Hill section of Bethlehem. With its many prominent owners, including a militia general, a wealthy publisher, a prominent politician and a noted defense attorney with shady clients, this property has hosted many social gatherings over the years. Fittingly, the party continues today with its use as a private home hosting weddings and other events.

Just before the entrance to Henry Hudson Town Park, one notices the sweeping lawn that leads up to a striking, large home. Today, it presides over rumbling trucks and flashing cars traveling on Route 144. In the early 1800s, this area was home to the quiet country retreat of General John Taylor Cooper. Cooper was a prominent Albanian whose winter home was a mansion on State Street reputed to have been designed by Philip Hooker. Cooper was a land agent for New York State, lawyer with Bloodgood and Cooper and an officer with the New York Militia.

Cooper died in 1878, and in the late 1880s, James B. Lyon acquired the two-hundred-acre parcel that stretched from River Road east to the Hudson River and south to the Vlomankill. Lyon transformed Cooper's more modest home into a comfortable summer retreat. Lyon was the owner of a successful publishing and printing company and other business interests in Albany. By his retirement in 1916, he and his wife, Anita, were living here year round.

Lyon was a generous man who apparently liked to have his friends near him. He gave parcels of land to two friends, Dr. Willis G. MacDonald and Martin H. Glynn, so they, too, could enjoy the cool countryside of Cedar Hill away from the summer heat of Albany. In 1907, Glynn hired architect Marcus T. Reynolds to fulfill his ideas of a Mediterranean-style villa with a red tile roof and stuccoed walls. The U-shaped house featured a columned terrace on the south side with wings enclosing the north-facing courtyard with its circular drive leading to an elegant inset columned entry. Although much altered, this is the home that stands today. Glynn's summer home was built close to Lyon's retreat. MacDonald's home is just to the north. One imagines much summer socializing among the three families.

Glynn was elected lieutenant governor in 1913 and, following the impeachment of Governor William Sulzer, became governor of New York from 1913 to 1914. The August 17, 1913 issue of the *New York Times* features a photo spread of the new governor with his wife, Mary, at their

An aerial view of the mansion taken in the early 1960s highlights the U-shaped elegance of the mansion. *Courtesy of Danielle Marvelli and Brian Kelly.*

Some remember when the mansion looked like this circa 2004 snapshot. Drive down River Road today to see the façade totally renovated and elegant. *Courtesy of Danielle Marvelli and Brian Kelly.*

country home at Cedar Hill. While prominent in political circles, Glynn was also a noted journalist who became owner, publisher and editor of the *Albany Times Union.*

Two years after Glynn's death in 1924, the house was acquired by Daniel H. Prior, who had it converted to a year-round residence for himself and his family. Prior has been called the greatest trial attorney of his time. Michael Friedman, in his blog post for the Albany County Bar Association, notes, "Long before he represented Legs Diamond across the Hudson, his unsuccessful defense of Anna Antonio was one of the great works of legal advocacy of 20th Century in Albany." Diamond was a famous Prohibition-era gangster and rumrunner. An unpublished history of the mansion notes that Diamond "lived at the Prior estate while out on bail in his criminal lawyer's custody. Prior was able to get Diamond out of his shooting incident trouble, and Diamond paid him by giving him some Great Danes."

After Prior's death in 1953, his widow and daughter moved into the gatehouse and closed up the big house. The Bethlehem Elks, organized in the fall of 1961, purchased the Prior estate in 1962. Prior himself belonged

to the Albany Elks Lodge. The Elks made considerable changes to the mansion, including adding a large multipurpose room by enclosing the courtyard between the wings of the building, creating a bar and cocktail lounge out of the dining room and removing upstairs partitions between bedrooms to create another meeting space.

When Marvelli and her husband, Brian Kelly, drove by the mansion in 2004 and saw the for sale sign, they were intrigued by the possibilities of this unique property. A tour of the building revealed the 1970s-era style and flair of the Elks paired with the elegant architectural details still visible from the Glynn and Prior eras. They immediately fell in love with the place, purchased it and started restoration work. Today, Marvelli and Kelly have created a welcoming home to raise their family, as well as an elegant venue for special events.

Chapter 34

VAN WIES POINT SUMMER HOMES

This article appeared in the April 2015 issue of Our Towne Bethlehem.

Nowadays, we don't think of Bethlehem as a summertime destination, yet at the turn of the twentieth century, wealthy people from Albany often escaped the city heat by traveling to their Van Wies Point summer homes. Notable homes include artist Erastus Dow Palmer's Appledale, Dr. William Hailes's Bonnie Castle and Chauncey Hakes's Rock Ledge.

In May 1892, the *Altamont Enterprise* reported, "E.D. Palmer has removed from Albany to his country seat, Appledale, for the summer." Interestingly, the location is listed as Wemple, a Bethlehem hamlet little recognized today. In 1927, when Appledale was owned by the Lochnars, it was described as a rambling old place with unexpected wings. At the time, it still contained a dining room table hand crafted by Palmer without using nails. A painting by Palmer's son Walter Launt Palmer called *Dining Room at Appledale* shows the fireplace mantel that Palmer also designed. Erastus Dow Palmer (1817–1904) was working as a carpenter when his talent as a sculptor first came to light. He went on to an illustrious career in the art world.

Also in the 1890s, Dr. William Hailes and his wife, Bertha, made Van Wies Point their summer destination. Their Bonnie Castle was built in 1891 on a rise of land on the shore of the Hudson River and features two towers, wrapping porches and sweeping river views. It included their unique "seven seas room," a hall and stairway whose walls and ceiling were covered with shells and pebbles collected by Dr. Hailes during his travels. The Haileses,

Dining Room at Appledale by Walter Launt Palmer. *Courtesy of the Albany Institute of History and Art.*

including children William and Dorothy, lived on Hamilton Street in Albany when not enjoying the summer at Van Wies Point.

After Dr. Hailes's death in 1912, Bertha continued to use the property and is listed as resident there in the 1915 New York State census, along with the

A man on a bicycle can be seen in this view of Bonnie Castle at Van Wies Point. The porches on the right face the Hudson River. *Courtesy of the Bethlehem Historical Association.*

A modern view of Rock Ledge on Van Wies Point. *Courtesy of the author.*

children, who were young adults by then. William Jr. is listed as an electrical engineer; he would go on to serve with the U.S. Navy during World War I. Interestingly enough, on the same census page are Chauncey and Anna Hakes, nearby residents of Rock Ledge.

Among the many metes and bounds descriptions found in the deed for Rock Ledge, among the iron pipes, chicken coops and docks, is the "fence at the top of a rock ledge." Rock Ledge the home sits high above the Hudson River on the eponymous rock. In 1909, L. Melius sold the property to Chauncey D. Hakes. While it is unclear whether Melius or Hakes built the home, Anna and Chauncey Hakes certainly enjoyed it for many years, often staying well past summertime. The December 26, 1913 *Altamont Enterprise* carries a report that they had closed their summer home at Van Wies Point and taken apartments at Chestnut Street in Albany for the winter. Eventually, they made Rock Ledge their year-round home.

Hakes began his career as a shoe dealer and advertised his store on South Pearl Street in Albany with its "popular prices." A member of the Albany Automobile Club, he eventually turned his passion for automobiles into a successful venture with the Albany Garage and the Hakes and LeBourveau auto dealership. His obituary, published in June 1956, notes he was one of the early enthusiasts of the "gas buggy," including early models of the Franklin and Pierce automobiles. Over the years, both Chauncey and Anna (as Mrs. Chauncey D. Hakes) are noted many times in the newspapers for their efforts on behalf of the Albany Chapter of the American Red Cross. Chauncey was a staunch member of the community active with the Elks, Masons and Rotarians and was a leader in the chamber of commerce.

Van Wies Point itself traces its European roots to Hendrick Gerreitse Van Wie, an early Dutch colonist who built a house here in 1679. The People of Colonial Albany Project reports that Van Wie likely came to Rensselaerswyck in 1664. He was married to Eytie Ariaans and died in 1692. In the 1830s, descendants Peter and Henry Van Wie leased a dock here to the Hudson River Steamboat Company for its Albany terminal. At that time, the Hudson River was too shallow for the steamboats to safely get to Albany. In the mid- to late 1800s, large ice warehouses also made an appearance at Van Wies Point.

Today, as one travels on Van Wies Point Road from Bonnie Castle with its Victorian turrets to Rock Ledge and its Colonial feel, one can enjoy a wide variety of architectural styles, including sleek modern designs and even an octagonal house.

Chapter 35

THE SUBURBS

Previously published in Our Towne Bethlehem *in July 2014.*

One way to trace history in Bethlehem is by looking at how land use has changed over the years. For thousands of years, Native Americans looked to the land to support their way of life, utilizing the dense forests, untamed rivers and fertile soils found here. Early European setters (in our area mainly the Dutch) set out to exploit these natural resources, especially the beaver. In the late 1600s and early 1700s, the Van Rensselaers established their manor, laid out farmsteads and began renting them out.

By the time of the American Revolution, Bethlehem was characterized by farms, primarily along the Hudson River, Normanskill and Vlomankill. Albany was recognized as the urban center. As the population grew, Bethlehem was formally established in 1793. Folks settled into the farming lifestyle, with hamlets like Adamsville (now Delmar) and Kimmeys Corners (now South Bethlehem) developing around the schoolhouse and church, blacksmith and general store, tavern and inn.

Change continued as improved transportation options took hold. The commuting lifestyle started in the 1870s with the Albany and Susquehanna Railroad (later the D&H) in the northern part of town and the West Shore Railroad in the southern. Enhanced roads, bus service and, of course, the automobile continued the suburbanization of Bethlehem.

Following national trends, and especially after World War II, the subdividing and marketing of bucolic Bethlehem really got underway.

While Louise Street is not located in Kenholm Gardens, this circa 1955 photo captures the popular curved street and ranch-style homes of the era. *Courtesy of the Bethlehem Public Library.*

Low-cost mortgages, FHA housing standards and developing highway networks contributed to suburban development, as did the idea of the American dream: a freestanding home on a landscaped lot away from the urban core.

Kenholm Gardens is just one example among many in the town of Bethlehem. It began in the mid-1950s when Harold J. Magee began to subdivide his land and continued in the 1960s with the Kenholm Construction Corporation under the leadership of William Zautner. The gently curving streets of Dumbarton, Devon, Greenock and Brookview were advertised as "a lovely place to live." Leo Denault, who has lived on Devon Road for forty-seven years, would add that it is a great place to raise a family. He and his wife, Elizabeth, raised their six children here. Indeed, two daughters have moved back into the neighborhood to raise their own families.

Advertising highlighted the subdivision's pool, a "delightful, refreshing, summer enjoyment" that continues to this day. Longtime resident Bob

Kids get ready to jump in the Kenholm Garden pool in this modern photo. *Courtesy of Jennifer Baniak-Hollands.*

Horn remembers many years of camaraderie working with the Pool Association on various maintenance projects, especially in 1967 when the concrete pool floated a foot or more out of the ground. In the summer months, the pool remains a neighborhood hub with membership open to all, not just homeowners as was the case in years past.

Today, sociologists and government planners are making the argument that the age of the suburb is drawing to a close. While change is constant, consider this quote written on a cuneiform clay tablet to the king of Persia in 539 BC (as quoted by Kenneth T. Jackson in *Crabgrass Frontier: The Suburbanization of the United States*): "Our property seems to me the most beautiful in the world. It is so close to Babylon that we enjoy all the advantages of the city, and yet when we come home we are away from all the noise and dust."

Chapter 36

THE PALMER HOME IN SOUTH BETHLEHEM

Previously published in the June 2014 issue of Our Towne Bethlehem.

On South Street in South Bethlehem, one cannot get any farther south in the town than Nicole and Michael Keenan's Italianate home. South Bethlehem boasts an abundance of Italianate-style houses, with their broad eaves supported by large brackets, nearly flat roofs, towers and cupolas. They point to the historic nature of the hamlet and suggest its age. The Italianate style was introduced to the United States in the 1840s and persisted through the 1870s.

Records hint that the Keenans' home was likely built by the Schaupp family prior to 1880, maybe as early as the 1860s. Frederick Schaupp, a native of Germany, and his wife, Hester Willsey, turn up in the New York State census in 1855, residing in South Bethlehem. The census notes that Frederick had been a resident for only three years, while Hester had lived there all her life.

Fifteen years later, in the 1870 U.S. census, Frederick and Hester are raising their family, including son Alonzo, age thirteen, and their infant daughter, Hannah. Frederick, a tanner, owns real estate valued at $2,000, a sizable sum in 1870. He is active in village life, including the South Bethlehem United Methodist Church and the Mount Pleasant Cemetery Association. Throughout the late 1880s and '90s, the Schaupps are mentioned often by the South Bethlehem correspondent to the *Altamont Enterprise*, including the September 1887 elopement of young Hannah,

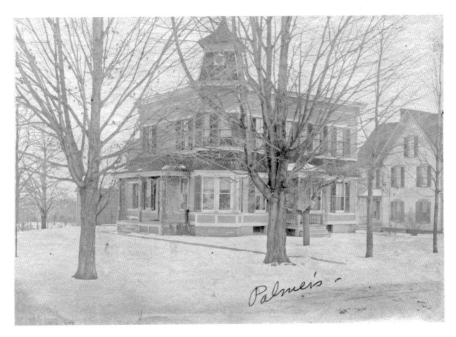

The Palmer House about 1920. *Courtesy of Bob Griffin.*

A bedroom in the Palmer House is seen about 1920. This photo and the one of the house were taken by Hattie Van Atten Griffin. Hattie was a young woman at the time who lived two doors down from the Palmers on South Street in another lovely Italianate home. *Courtesy of Bob Griffin.*

which caused "much excitement in our usually quiet village." In the fall of 1889, the paper noted that "Mr. A. Schaupp is now superintending Mr. Callanan's pavement in the village of Saugerties."

The Schaupps—Frederick (1827–1906), Hester (1832–1910), Alonzo (1857–1915) and his wife, Ana (1857–1895)—are all buried at Mount Pleasant Cemetery in South Bethlehem.

The actual location of the Schaupps' property is somewhat murky at this time. An 1866 map indicates the Schaupp property is near today's Willowbrook Avenue. On the other hand, the 1880 U.S. census notes that the Schaupps' is the last dwelling to be surveyed in the village, which makes sense as the Keenans' home is the last before the town line. What is perfectly clear is that Alonzo Schaupp, whom the deed describes as "unmarried being a widower," sold the property to Jessie M. Palmer in 1903.

From 1903 until 1945, the property was owned by Jessie and Edwin Palmer. They moved to South Bethlehem sometime after 1892, when, according to the New York State census, they were living in Coxsackie with their two-year-old son Alden. In the 1900 census, they are renting in South Bethlehem and Edwin is working as a grocer. Alden is "at school." By the 1910 census, Edwin is an engineer at the stone quarry. The stone quarry is the same Callanan's that Alonzo Schaupp and many others in the hamlet worked for.

An Update

After this article was published, an abstract of title for the Palmer property came to light. It reveals that the Palmers' home was once part of a two-hundred-plus parcel owned by Jacob Kimmey as early as 1818. It went from members of the Kimmey family to members of the Callanan family in the early 1860s. The large tract was clearly subdivided by the time a transfer was made from James and Martha Callanan to Alonzo Schaupp in 1886. Schaupp sold to Palmer in 1903, and Palmer sold to Donald and Caroline Tullock in 1945.

Chapter 37

THE SAGER-BREEZE HOUSE

Previously published in the March 2015 edition of Our Towne Bethlehem.

Did you ever notice the flag-draped building near the roundabout in Slingerlands? This old Greek Revival–style farmhouse is the law office of John Breeze. Breeze flew a smaller flag during the troubled days surrounding September 11, 2001, but didn't have a flagpole, so he attached it to the house. By 2003, the flag had reached the size it is today. As Breeze puts it, he has taken the view that "we have to earn our freedom every day" and that "if we don't remember that our freedoms are not free, we will lose them."

The house itself was probably built in the mid-1800s by one J. Slingerland. Sanford and Martha Sager were living in Guilderland in 1892. By 1900, the Sager family was living here. The 1905 New York census provides a snapshot of the family. Sanford, age forty-two, is listed as the head of the household and a farmer. Martha, his wife, age thirty-nine, is keeping house. Their oldest son is Albertus, age twenty. He is listed as a printer, probably at the Slingerlands Printing Company just down New Scotland Road. Howard is next at age eighteen. He is a clerk with the Delaware and Hudson Railroad. The railroad station was also just down the road near today's Slingerlands Fire Department. Both Bert and Howard around this time were playing baseball with the Slingerland Village Wonders. The family is rounded out with Edna, sixteen; Ralph, fourteen; Elsie, nine; and William, five, all of whom

Right: This flag-draped
home is a landmark on New
Scotland Road near the
Slingerlands roundabout.
Courtesy of the author.

Below: Sanford (seated on
right) and Martha Sager
(kneeling behind young boy)
pose with family members at
the farmhouse in the early
1900s. Standing fourth from
the left is Howard Sager.
Courtesy of Ed Sager.

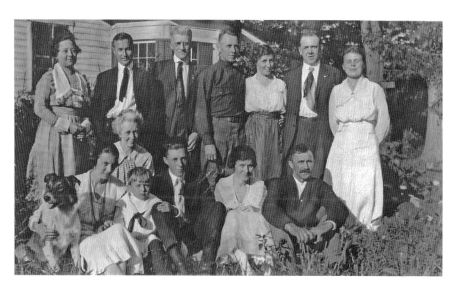

were at school. William Sager would also go on to play baseball with the Slingerland team.

Another glimpse is seen in New York's 1925 census. Sanford and Martha are still farming. Ralph, now age thirty-four and married to Hilda, lives with his parents. He is an auto salesman. Also still living at home is Elsie, age twenty-nine, who is a stenographer. A few flips of the census pages reveal that Bert Sager and his wife, Ada, are living down the street on New Scotland Road. Bert is an auto dealer. Interestingly, on the same page we have Charles Barnes in the auto business and Norman Williams Jr., also an auto dealer. The automobile revolution was certainly being felt in Slingerlands.

After Sanford Sager died in 1946, the house and approximately five acres eventually came to John Breeze in 1973. Breeze has adapted this historic structure into his law offices. Amid the roundabout bustle and the nearby development at the Vista campus, this elegant building speaks of a bygone era when the roundabouts were farmers' fields. The encompassing American flag speaks of the owner's commitment to freedom.

Chapter 38

THE SPRONG HOUSE

A version of this article appeared in the May 2014 edition of
Our Towne Bethlehem.

Number 698 Kenwood Avenue sits among a row of lovely Queen Anne Victorian homes that were developed by Albert I. Slingerland in the 1870s. At the time, this section of road was separate from Kenwood Avenue and directly across from the railroad tracks and the Slingerlands Station. Indeed, it appears that Slingerland marketed his homes to Delaware and Hudson Railroad executives.

On October 26, 1886, Albert and his wife, Catherine Slingerland, sold the house to Jessie White Sprong. At the time, Sprong was the assistant general passenger agent for the D&H; by 1889, he was the comptroller and purchasing agent for the entire Northern Railroad Department. He started his career with the D&H in 1874 and continued to his death in 1930. Sprong's obituary in the *Altamont Enterprise* notes that at the time of his death, he was the "Dean of the railroad purchasing agents in the United States."

Sadly, Sprong died just two days after his wife, Sarah. The obituary goes on to note that Slingerlands lost "two of its oldest and most distinguished residents. They had lived in their home for nearly half a century, having come to Slingerlands as bride and bridegroom." Sarah was known for her work with the local Red Cross chapter throughout World War I. The couple raised three children here: Elizabeth, Florence and Harwood. Elizabeth inherited the property and lived here until her death in 1960.

Left: J. White Sprong. *Courtesy of Sheri Sanduski.*

Below: J. White and Sarah Sprong's house on Kenwood Avenue in Slingerlands can be glimpsed through the palm trees in this circa 1900 photo. *Courtesy of Sheri Sanduski.*

Edgewood, as the property was known, was extensively landscaped by the Sprongs with elegant drives, large palms, rhododendrons and colorful bedding flowers. The house retains original architectural details both inside and out. Inside is an inscription in what was then wet plaster of the dining room dated December 2, 1874, and signed by the carpenter. The butler's pantry between the dining room and kitchen is completely intact, including a marble sink and wood cabinetry with original hardware. Outside, one sees shingle-covered gables, broad porches and windows accented with decorative wood lintels. Since moving here in 2002, the current owners have continued to restore the home. It was listed on the State and National Registers of Historic Places in 2012.

ACKNOWLEDGEMENTS

As the saying goes, it takes a village—or, rather, a hamlet, as we like to say in Bethlehem. Many, many thanks to the following folks who helped with the creation of this book: town supervisor John Clarkson and the Bethlehem Town Board (you found me an office at town hall); Robin Nagengast, Nanci Moquin, Susan Alexander and many other town hall denizens (general encouragement); Karen Beck and the Bethlehem Historical Association (local history at its finest); the Bethlehem Public Library (comfy café tables, free Ancestry.com and toddlers going to story time for inspiration); Sharon Schultz, Steve Baboulis and Charlene Hesse (title help and yummy food); Elise Gibney (all that walking and talking); Garry McBride (a well-timed "you can do it!"); Whitney Landis and Stevie Edwards of The History Press (just the right amount of e-mails); and, of course, my family, John, Colin and Emma, for putting up with all my historical hijinks.

Bibliography

Albany County Post. Historic Newspapers. fultonhistory.com/Fulton.html.

"Albany County Revolutionary War Pensions." revolutionarywarpensions. tripod.com/flansburgh.j.htm.

Albany Evening News. Historic Newspapers. fultonhistory.com/Fulton.html.

Albany Knickerbocker News. Historic Newspapers. fultonhistory.com/Fulton. html.

Altamont Enterprise, July 1888 to December 2008. historicnewspapers.guilpl. org.

Ames, David L. *National Register Bulletin Historic Residential Suburbs*. Washington, D.C.: National Park Service, 2002.

Annual Report of the New York Public Service Commission 6, no. 1.

Baldwin, Simion E. *Life and Letters of Simeon Baldwin*. New Haven, CT: Tuttle, Morehouse & Taylor Co., 1918.

Bennett, Allison. *More Times Remembered*. Delmar, NY: Newsgraphics, 1987.

———. *Times Remembered*. Delmar, NY: Newsgraphics, 1984.

Berlin, Ira, and Leslie Harris, eds. *Slavery in New York*. New York: New Press, 2005.

Bethlehem Public Library 2013–14 Annual Report. www.bethlehempubliclibrary. org.

Bethlehem Town Board Minutes of Meetings 1794–1833. Town of Bethlehem Archive.

Bielinski, Stefan. "Albany County." www.nysm.nysed.gov/albany/ albanycounty.html.

Board of Geographic Names Report. Museum Bulletin 173. New York State Department of Education. November 1, 1914.

Brewer, Floyd, ed. *Bethlehem Revisited: A Bicentennial Story, 1793–1993*. Bethlehem, NY: Town of Bethlehem Bicentennial Commission, 1993.

———. "The Goes/Van Derzee Farm Site." *Bulletin Journal of the New York State Archaeology Association* 117 (2001).

Child, Hamilton. *Gazetteer and Business Directory of Albany & Schenectady Co. N.Y. for 1870–71*. Syracuse, NY: Journal Office, 1870.

Christoph, Florence. *Upstate New York in the 1760s*. N.p.: Picton Press, 1992.

Christoph, Florence, and Peter R. Christoph, eds. *Records of the People of the Town of Bethlehem*. Selkirk, NY: Town of Bethlehem Historical Association, 1982.

Christoph, Peter R. *A Norwegian Pioneer in a Dutch Colony: The Life and Times of Albert Andriessen Bradt*. N.p.: P.R. Christoph, 2006.

Clark, Rufus. *The Heroes of Albany: A Memorial of the Patriot-Martyrs of the City and County of Albany*. Albany, NY: S.R. Gray Publisher, 1866.

Cooper Family Papers, 1796–1877. Catalog Record. New York State Library Manuscripts and Special Collections.

Cornell Cooperative Extension. "4-H Takes You Places." albany.cce.cornell. edu/4-h-youth/about-4-h.

Daughters of the American Revolution Tawasentha Chapter. *Pilgrimages to the Graves of 126 Revolutionary Soldiers in the Towns of Guilderland, New Scotland and Bethlehem, Albany County, New York*. Slingerlands, NY: Daughters of the American Revolution Tawasentha Chapter, 1940.

David Rumsey Map Collection. www.davidrumsey.com. 1891 Beers Atlas.

Davids, Dorothy. *A Brief History of the Mohican Nation Stockbridge-Munsee Band*. Bowler, WI: Stockbridge-Munsee Historical Committee, 2004.

Doings of the Commissioners of Highways. Town of Bethlehem Archive.

Drew, J.M. *Farm Blacksmithing*. St. Paul, MN: Webb Publishing Company, 1910.

Drew. "Questions About Methodism." www.drew.edu/library/methodist/faq#m2.

Dunn, Shirley W. *The Mohicans and Their Land, 1609–1730*. Fleischmanns, NY: Purple Mountain Press, 1994.

Dutch Barn Preservation Society. dutchbarns.org.

Folk, Cynthia G. *Barns of New York: Rural Architecture of the Empire State*. Ithaca, NY: Cornell University Press, 2012.

Geddes, George. *The General Plank Road Law of the State of New York*. Syracuse, NY: Stoddard and Babcock, 1849.

Grieco, Louise. *They Built Better Than They Realized: A Centennial History of the Bethlehem Public Library*. Delmar, NY: Bethlehem Public Library. 2013.

Groesbeck Papers, Town of Bethlehem Archive.

Helderberg Sun. "Bethlehem Elks Meet in Historic Landmark." March 7, 1978.

Howell, George Rogers, and Jonathan Tenney. *Bi-centennial History of Albany County*. New York: Munsell & Co., 1886.

Internet Movie Database. imdb.com.

Jackson, Kenneth T. *Crabgrass Frontier: The Suburbanization of the United States*. London: Oxford University Press, 1985.

Kenholm Gardens: A Lovely Place to Live. Advertising brochure, Town of Bethlehem Archives.

Kenney, Alice P. *Albany Crossroads of Liberty*. Albany, NY: City and County of Albany American Revolution Bicentennial Commission, 1976.

Key Bank history. fundinguniverse.com/company-history/keycorp-history.

Leath, Susan E. *Bethlehem*. Charleston, SC: Arcadia Publishing Images of America Series, 2011.

Mulligan, E. Thomas, Jr. "Adams House, Delmar, N.Y." Unpublished manuscript, Bethlehem Town Archive.

Munsell, Joel. *The Annals of Albany*. Albany, NY: Joel Munsell, 1869.

"New York Civil War Muster Roll Abstracts." www.ancestry.com.

New York State Military Museum. dmna.state.ny.us/historic/mil-hist.htm.

Parker, Amasa. *Landmarks of Albany County*. Syracuse, NY: D. Mason, 1897.

Passenger and Freight Stations on the Delaware and Hudson. Albany, NY: Delaware and Hudson Company, 1928.

The People of Colonial Albany Project. www.nysm.nysed.gov/albany/index.html.

Plank Road Manual Including the General Law of Plank Roads and Turnpikes of the State of New York. Rochester, NY: Harrison and Luckey Printers, 1848.

"The Prior Estate." Undated, typewritten manuscript, Town of Bethlehem Archive.

Records of Bethlehem for the Purpose of Intering Negro Children Born of Slaves from this 4th Day of July 1799. Town of Bethlehem Archive.

Records of Roads 1833–1899. Town of Bethlehem Archive.

Reynolds, Cuyler. *Hudson-Mohawk Genealogical and Family Memoirs*. New York: Lewis Historical Printing Company, 1911.

Roberts, James A. *New York in the Revolution as Colony and State*. 2nd ed. Albany, NY: Brandow Printing Company, 1898.

Selkirk, James Sergeant. "A Memoir of the Revolutionary War." Unpublished manuscript, Town of Bethlehem Archives.

Shaughnessy, Jim. *Delaware and Hudson: The History of an Important Railroad Whose Antecedent Was a Canal Network to Transport Coal.* Syracuse, NY: Syracuse University Press, 1997.

Sible, William, Bethlehem town clerk, comp. "New York Town Clerk's Registers of Men Who Served in the Civil War." www.ancestry.com.

Stewart, L. Lloyd. *A Far Cry from Freedom: Gradual Abolition, 1799–1827.* Bloomington, IN: Author House, 2006.

Stimson, Alexander Lovett. *History of the Express Business: Including the Origin of the Railway System.* New York: Baker & Godwin, Printers, 1881.

"Town of Bethlehem War Council Final Report to the Town Board of the Town of Bethlehem." Town of Bethlehem Archives, 1946.

Tri-village Area Directory: Delmar, Elsmere and Slingerlands Suburbs of Albany, New York. N.p.: Tri-Village Directory Association, 1933–1993.

"The VanRensselaer Manor Papers." New York State Library. Manuscripts and Special Collections Virtual Exhibit. www.nysl.nysed.gov/mssc/vrm/h5antirent.htm.

War of 1812 Pension Application File. www.ancestry.com.

Weintraub, Aileen, and Shirley W. Dunn. With paintings by L.F. Tantillo. *The Mohicans.* Fleischmanns, NY: Purple Mountain Press, 2008.

Widner, James F. "Floyd Phillips Gibbons." Old Time Radio. www.otr.com/gibbons.shtml.

Index

ABOUT THE AUTHOR

Town historian Susan E. Leath has been a resident of Bethlehem for over twenty years. She attended her first Bethlehem Historical Association meeting in September 1995 and was soon volunteering and immersing herself in Bethlehem history. Her graduate work in museum studies at Brown University and her tenure as director of the Florence (South Carolina) Museum of Art, Science and History have served her well as she explores what objects and documents reveal about our history. Leath was appointed town historian in 2007, a position she continues to enjoy with its random historical inquiries, educational walks, talks and exhibits and "Then & Now" articles. Susan is the author of *Bethlehem*. Check out her blog at BethlehemNYHistory.blogspot.com.

Visit us at
www.historypress.net
...
This title is also available as an e-book